Zentrum Paul Klee
Bern

Short Guide

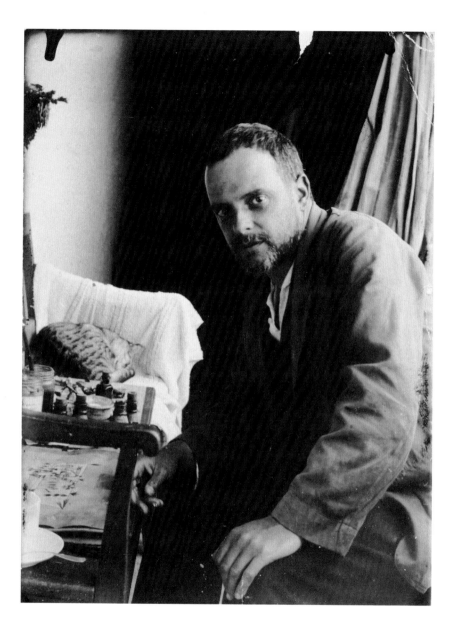

Zentrum Paul Klee
Bern

Short Guide

Hatje Cantz

Contents

Foreword

Dear Readers,

The short guide to the Zentrum Paul Klee, which you have in your hand, is the first documentation of the multi-discipline approach intended by the center's founders and patrons, Prof. Dr. Maurice E. Müller and Martha Müller-Lüthi. The initiative of building a museum in Bern dedicated to Paul Klee, thereby providing a suitable backdrop for the estate of Paul and Lily Klee, started with the grandson Alexander Klee. The project was given a clear outline by the conditions attached to the donation by the artist's daughter-in-law, Livia Klee, of Paul Klee works to the city and canton of Bern. The location and the philosophical direction of a cultural center are thanks to the gifts and the vision of Prof. Dr. Maurice E. Müller and Martha Müller-Lüthi.

Paul Klee practiced the fine arts. But that was not all. He was an excellent violinist all his life, he was a gifted teacher, he was a writer and an art theorist. At the Zentrum Paul Klee, we aim to showcase all these areas of activity.

We want to communicate with a broad spectrum of the population. Read the manifesto which is printed in this guide (p. 20–21). We are grateful for feedback. And suggestions as to how we can improve our service will be particularly welcome.

We wish you an exciting time at the Zentrum Paul Klee and hope you will soon come back to see us again.

Andreas Marti
Founding Director Zentrum Paul Klee, Bern

Paul Klee in Bern: From the Settlement of the Estate to the Zentrum Paul Klee

Stefan Frey, Christine Hopfengart, and Ursina Barandun

Paul and Lily Klee's Emigration to Switzerland

Paul Klee, who had been living in Germany since 1906 and since the late 1920s had been regarded as one of the most respected artists of the modern age, was to feel the effects of persecution by the National Socialists soon after they took power on January 30, 1933. He was publicly denounced as a "decadent artist," lost his most important art dealership when the Galerie Alfred Flechtheim in Düsseldorf and Berlin was closed, and on April 21, 1933, he was suspended from his teaching duties at the Staatliche Kunstakademie (State Art Academy) in Düsseldorf—effective immediately. This forced him to seek a completely new orientation of his finances. His wife urged him to leave Germany. Klee and his wife decided to go to Bern, where Lily arrived on December 20, 1933, and Paul on December 24. Once there, Paul Klee, a German citizen, applied for Swiss citizenship at the earliest available opportunity—in the spring of 1939. His application was virtually certain to have been approved, but Klee died on June 29, 1940, while on a rest cure at the Clinica Sant'Agnese in Locarno-Muralto.

Lily Klee administered her husband's artistic estate as sole beneficiary—in 1933 her only son, Felix, and his wife Ephrosina remained in Germany, where they had built up careers as a theater director and a singer respectively; their only child, Alexander, was born in 1940. The Klees' friend and advisor, Bern insurance agent Rolf Bürgi, assisted Lily Klee in business matters. She gave him an official mandate to do so in the autumn of 1941.

Lily Klee, in Lucerne?,
summer 1946

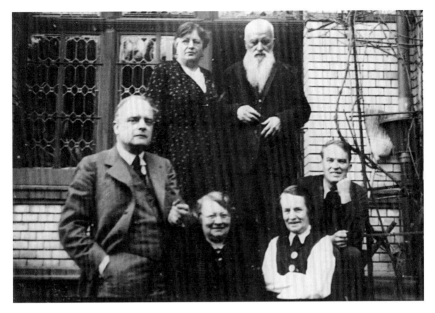

Mathilde and Hans Klee, Paul and Lily Klee, Gertrud and Will Grohmann
(left to right, top to bottom), Obstbergweg 6, Bern, mid-February/March 1935

The Klee-Gesellschaft and the Origins of the Paul-Klee-Stiftung

There was a real danger that, upon the death of his widow, Paul Klee's Estate of
some six thousand works could be sold for the benefit of the Allies under the
Washington Agreement, which regulated the disposal of assets in Switzerland be-
longing to Germans living in Germany. Therefore, on September 20, 1946, two
days before Lily Klee's death, Rolf Bürgi sold the entire artistic estate of Paul Klee,
including the publication rights and the artist's library, to Bern businessman Herr-
man Rupf and Bern publisher Hans Meyer-Benteli for 120,000 Swiss francs. These

Rolf Bürgi, Bern, January 1927

Paul and Felix Klee with Hermann and Margrit Rupf-Wirz (left to right) in front of St. Ursus's Cathedral in Solothurn, 1937

two men, jointly with Rolf Bürgi and the Bern architect Werner Allenbach, founded the Klee-Gesellschaft (Klee Society) on September 24, 1946, and took possession of the Paul Klee Estate. All four were Klee collectors and were well aware of the artist's desire to leave his estate inalienably to a Swiss museum. They therefore called the Paul-Klee-Stiftung (Paul Klee Foundation) into being on September 30, 1947 with the aim of creating "an artistic legacy which could not be sold," and of setting up one of "the places in Switzerland open to serious art research." The foundation began with more than 1,700 works from the Paul Klee Estate, a number of written documents, and the artist's library. Three years later, the four founders increased that by another 1,500 works which they classified chiefly as rough drawings and sketches.

Felix Klee: In the Service of the Artistic Legacy

Felix Klee, the artist's son, was able to move to Bern from Germany with his wife and child following an invitation by the Klee-Gesellschaft. The following year, he made a claim for the entire estate of Paul Klee. The ensuing four-year legal battle with the Klee-Gesellschaft concluded at the end of 1952 with the parties agreeing out of court as follows: the contract of sale of September 20, 1946 was canceled; Felix Klee recognized the Paul-Klee-Stiftung as a legal entity; the Paul Klee artistic Estate was transferred to him as his parents' sole heir, with rights and duties; the Klee-Gesellschaft was dissolved on December 31, 1952. The Paul-Klee-Stiftung had to surrender most of the 1,500 works it had acquired in 1950 to Felix Klee. But even then, the foundation still had a total of 40 panels, 161 color pictures, 2,251 monochrome pictures, 10 sketchbooks, 11 sculptures, 27 *verre églomisé* pictures, 87 prints, as well as Klee's art teaching and literary records. All the members of the Klee-Gesellschaft except Hermann Rupf left the foundation council; Felix Klee joined it, and was to be its president from 1963 to 1990.

Felix Klee

In early 1953, Felix Klee took possession of a total of 97 panels, 414 color pictures, 614 monochrome pictures, 4 statuettes, 2 reliefs, 13 *verre églomisé* pictures, 41 prints, and 69 pictures by artists who had been friends of Paul and Lily Klee. He also received personal documents written by or about Paul and Lily Klee. These things he added to his own collection: 30 hand puppets made for him by his father between 1916 and 1925, and a few paintings.

His collection was then the largest Klee collection in private ownership. Felix Klee, who worked as a radio play director and presenter on Swiss radio, administered the collection alongside his career, presenting it at more than fifty exhibitions in Europe, America, and Asia between 1955 and his death in 1990. He was generous in lending the works, making pieces available to more than sixty Klee solo exhibitions and countless group exhibitions. Alongside his exhibition work, he became very active in publications, thereby exerting a great deal of influence on the "Klee community." In 1989, he first publicly expressed an intention to use his collection to set up a family foundation. To what extent and under what conditions this should happen, however, was still unclear when he died unexpectedly on August 13, 1990.

Felix Klee's Legacy: The Livia Klee Donation and Alexander Klee's Permanent Loans

Alexander Klee, who inherited a collection of sixty-three Klee works from his Aunt Mathilde—Paul Klee's sister—in 1953, and who works as a painter and graphic artist under the pseudonym Aljoscha Ségard, took over the duties which fell to him as representative of the Klee family from his father Felix. He joined the council of the Paul-Klee-Stiftung in 1971 and has been its chairman since 1990. In the autumn of 1992, he proposed to Hans Christoph von Tavel, the then director of the Bern Kunstmuseum, that a Paul Klee museum be set up. The museum administration and the authorities from the city and the canton of Bern took the practical planning of the museum in hand after Alexander Klee and his stepmother Livia

Alexander Klee

Klee-Meyer—the heirs of Felix Klee—had indicated that they would permanently loan substantial parts of their collection to the Kunstmuseum Bern. The two of them divided up the works of art from the estate of Felix Klee in 1995. On May 14, 1997, Livia Klee-Meyer transferred virtually all the works of art which had fallen to her to the city and the canton of Bern under a donation agreement that these public authorities would erect a museum to Paul Klee by the year 2006. In mid-1998, Alexander Klee contracted to make selected works from his part of the Felix Klee Estate and from the former collection of Mathilde Klee available on perma-

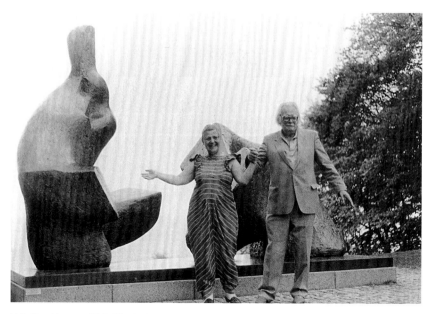

Livia Klee-Meyer and Felix Klee in the Louisiana Museum park, Humlebæk, 1986

nent loan to the Zentrum Paul Klee. He also signed an agreement on the deposit of the rest of the works belonging to him at the Zentrum Paul Klee.

Thanks to the cooperation of Felix Klee's heirs, substantial parts of the estate of Paul and Lily Klee, divided up in 1947, have been permanently reunited at the Zentrum Paul Klee, more than fifty years after the founding of the Paul-Klee-Stiftung by the Klee-Gesellschaft.

The Paul-Klee-Stiftung (1947/1952–2004)

For more than fifty years, the Paul-Klee-Stiftung (Paul Klee Foundation) was the academic center of competence for Paul Klee research. With some 2,600 paintings, drawings, and color works on paper, it had the world's largest collection of Paul Klee works, and in the course of its existence it had developed into a unique place for documentation and research. It made a significant contribution to Bern securing itself a place on the map of the classic modern age.

At the time it was founded in 1947, it was not certain where the Paul-Klee-Stiftung would find its permanent home. Along with the Kunstmuseum Bern, the museums in Basel and Zürich had also shown an interest. The foundation council even considered building its own Klee museum. Max Huggler, the then director of the Kunstmuseum Bern, was able to settle the question to the advantage of his own establishment. From then on, the foundation was located at the Kunstmuseum, and the two institutions came to work in close cooperation. The Kunstmuseum based

The rooms of the Paul-Klee-Stiftung in the Kunstmuseum Bern in the 1950s

Jürgen Glaesemer, Paul-Klee-Stiftung
custodian from 1977 to 1988

its international reputation on the Klee collection, while the Paul-Klee-Stiftung obtained permanent exhibition space and was able to benefit from the infrastructure of a working museum concern. The collection was inventoried, underwent restoration where necessary, and was put on display in 1956 within the framework of a major retrospective. As Klee grew in popularity, the works were loaned to other museums more and more often, particularly to museums abroad; the first "export exhibition"—to Japan—took place in 1961.

In the early 1970s, a new era in the life of the Paul-Klee-Stiftung began. The foundation no longer saw itself as a collection but as an art archive which was developing into a comprehensive Paul Klee research and information center. This new orientation came about at the same time as Jürgen Glaesemer took office. He was to set his stamp on the work of the Paul-Klee-Stiftung for seventeen years. Glaesemer published four comprehensive catalogues of the collection—providing the first overview of Klee's work since the 1950s. He also compiled a catalogue of works—a task in which he was assisted substantially by Felix Klee, the son of the artist. Glaesemer became a central figure in the history of the foundation and of Klee research. Paul Klee was for him a psychologically highly complex man, whose existential and artistic problems were only to be overcome with the help of a superior intelligence and a decidedly distanced, ironic outlook. Glaesemer laid the foundation stone for a deeper understanding of the artist, which included his theoretical work as well as his complex relationship with reality and the art of his time.

Following the premature death of Jürgen Glaesemer in 1988, Josef Helfenstein took the helm at the Paul-Klee-Stiftung. His time in charge (1988–2000) was largely dominated by the *Catalogue raisonné Paul Klee* project, the Paul-Klee-Stiftung's most comprehensive publication project ever. In this catalogue, more than 9,800 of Klee's works were listed, reproduced, and described along with their technical

Josef Helfenstein, Paul-Klee-Stiftung
custodian from 1988 to 2000

and historical details. Klee's own handwritten catalogue served as a basis for this work. In it, Klee had entered his works and given them consecutive numbers. A team of researchers worked for nearly fifteen years, examining collections all over the world, overseeing the printing and publication of nine comprehensive volumes. Under the project leadership of Christian Rümelin a special Klee database was created as an aid to research. It formed the basis of a unique digital museum database which is in use at many European museums today.

The death of Felix Klee in 1990 brought about a sea change in the historical direction of the Paul-Klee-Stiftung. On the initiative of the Klee family, the idea of a Klee museum took on a concrete form. The foundation council decided to incorporate the collection, the archive, the library, and the employees into the new institution of the Zentrum Paul Klee. Co-founders and main subsidizers of the project are the city and the canton of Bern. The agreement was sealed with the signing of a contract on September 1, 2000.

From 2001 to 2004, the work of the Paul-Klee-Stiftung took place under the direction of the new curator, Christine Hopfengart. It was aimed at preparing the way for the broader scope of the tasks to be faced by the Zentrum Paul Klee. A careful policy of loans extended the existing network of partner institutions, and new research projects such as an archive of Klee's pupils and the "Klee and Bern" project were initiated. In cooperation with the Institute for Media Studies at the University of Basel, a database of the pictures was developed as a fundamental research instrument which will be utilized at the Zentrum Paul Klee as a basis for visitor communication, research, restoration, and the digital loaning of images.

For half a century, the Paul-Klee-Stiftung was the central organ for the curation of, and research and information on, the works of Paul Klee. At the start of 2005, the Zentrum Paul Klee took over these tasks, and now continues and expands upon them—with the old and the new aims of finding out more about the many-layered

Christine Hopfengart, Paul-Klee-Stiftung
custodian from 2001 to 2004

work of Paul Klee, and of serving as an attractive and lasting forum for providing
information for a broad spectrum of the public interested in art and culture.

The Zentrum Paul Klee: Project and Execution

The idea of devoting a museum to Paul Klee in Bern originated with the artist's descendants. The decisive step was taken in 1997 by Livia Klee-Meyer, the daughter
of Bauhaus director Hannes Meyer and since 1980 wife of Felix Klee, when she
made her offer of a donation under certain conditions to the public authorities.
Upon acceptance of the donation, the city and canton of Bern became the owners
of nearly seven hundred works—simultaneously accepting the long-term duties
of building and administering a Klee museum by the end of 2006. In 1998, Alexander Klee made a legally binding promise to permanently lend 850 works and to
donate documents belonging to the family. In the same year, the Paul-Klee-Stiftung
announced its intention to be incorporated into the Zentrum Paul Klee along with
its inventory of some 2,600 works and its comprehensive archives. The amalgamation of these inventories and the obtaining of some 150 further permanent loans
from a number of private collectors have created the world's largest collection of
works by an internationally celebrated artist.

The first likely location for the new Klee museum was opposite the Kunstmuseum
Bern—the former schoolhouse which Klee himself had attended in its days as an
educational institution. A joint administration with the Kunstmuseum would have
allowed the exploitation of considerable synergies. The designers of a master plan
for the location also proposed a museum of contemporary art and the creation
of an academy under the auspices of the Institute of Art History at the University
of Bern. On the initiative of a number of Bern architects, the search began for
an alternative site which would make it possible to construct a new building in the
center of the city.

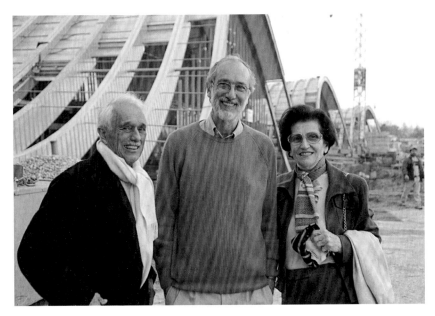

Maurice E. Müller, Renzo Piano, the architect, and Martha Müller-Lüthi
on the building site of the Zentrum Paul Klee, Bern, 2004

During the period of location evaluation (spring 1998) came the second tremendous offer of a donation in the history of the Zentrum Paul Klee. The world-famous Biel doctor and pioneering orthopedic surgeon Professor Maurice E. Müller and his wife, Martha Müller-Lüthi, expressed their willingness to donate two lots of land in the east of Bern (Schöngrün), along with a sum of at least 30 million Swiss francs. This offer came with the condition that the result would be more than just an art museum; rather, it was to be a center for the fine arts, music, literature, and theater; and the Italian architect Renzo Piano was to be commissioned with its design and execution so that the work of Paul Klee would be housed in a fitting building. In his first official statement on the donation, Maurice E. Müller said: "A Paul Klee center in Schöngrün is my vision. Here, the museum could benefit from the space and the atmosphere of this unique landscape. Paul Klee was himself a great teacher. It is my greatest wish that the Paul Klee museum in Schöngrün should also be a research center with teaching facilities attached to it."

From this point on, the Zentrum Paul Klee was designed and executed jointly by the Maurice E. and Martha Müller Foundation (founded November 4, 1998) as the builder and the public authorities (from September 15, 2000, the Stiftung Paul Klee-Zentrum [Paul Klee-Zentrum Foundation]) as the administrator. Three exhibitions were organized between 1999 and 2001 to familiarize the people of Bern and the politicians with the architectural project of Renzo Piano—because it was ultimately their decision whether this major undertaking should in fact

go ahead. The bill that went before the cantonal parliament included the canton's contribution (50 percent) to the cost of construction, the planning and development of the center, and the acquisition of the land. The cantonal parliament approved the bill on November 27, 2000, with 132 votes in favor and 7 abstentions. The bill for the city parliament contained an alteration to the zoning plan alongside these other provisions. On November 30, 2000, the city parliament passed the bill with all sixty-six members voting in favor. And on March 4, 2001, the electors of Bern approved it by an overwhelming majority, with 78 percent voting yes.

On October 15, 2001, the first earth was turned; on June 20, 2002, the foundation stone was laid, the topping-out ceremony was on December 1, 2003, and in November 2004, members of the administration and the Paul-Klee-Stiftung began moving into the building in the first of three steps in a phased-in occupation. The Paul-Klee-Stiftung was officially dissolved on January 1, 2005. Throughout the years of construction, members of the administration have guided thousands of people across the site and provided them with information on the project.

The cost of building the Zentrum Paul Klee ran to about 110 million Swiss francs. The founding family, the Müllers, doubled their contribution to 60 million. The canton of Bern lottery fund put in 18 million, and more than 30 million was generated by partnerships with business. Without the pioneering dedication of the

Maurice E. Müller and his daughters Janine Aebi-Müller and Denise Spörri-Müller at the laying of the cornerstone for the Zentrum Paul Klee, June 20, 2002

Peter Schmid, chairman of the Maurice E. and
Martha Müller Foundation, Renzo Piano, and Maurice
E. Müller at the laying of the cornerstone, 2002

founding partners and patrons, the creation of the Zentrum Paul Klee with its
wide spectrum would never have been possible.

The Burgergemeinde Bern (Civic Community of Bern) supports the Zentrum Paul
Klee with a sum of 20 million which is administered by the Paul-Klee-Stiftung der
Burgergemeinde Bern, founded in 2001. The interest this generates annually is spent
on activities of the Zentrum Paul Klee for which no regular funding is available.
Two additional foundations were inaugurated before the Zentrum Paul Klee com-
menced its work. One is the Fondation du Musée des Enfants auprès du Centre
Paul Klee, a foundation set up by the Müller family, whose capital of 5 million
Swiss francs can be invested in the running of the children's museum for a period
of six years; the other is the Stiftung Sommerakademie im Zentrum Paul Klee,
a training program run by the Berner Kantonalbank. For ten years, it will finance
the planning and carrying out of this training scheme, which is aimed at being a
kind of master class for young artists and art students, as well as offering evening
classes open to the wider public.

From the Vision to Everyday Function

The Zentrum Paul Klee is more than an art museum—it is a place which invites
the visitor to wholeheartedly engage with art and culture. The fine arts, music,
literature, and theater are not meant to merely coexist here; they are intended to
conjoin into ever new interdisciplinary forms of expression, thereby making a
valuable contribution for the wider public. It is important to us that visitors to the
Zentrum Paul Klee should know what to expect. And we hope that visitors will
tell us what they think in return. The model toward which the Zentrum Paul Klee
strives is as follows:

The Zentrum Paul Klee, with some four thousand works, has the world's most im-
portant collection of paintings, watercolors, and drawings, as well as archives

and biographical material from all Paul Klee's creative periods. The central task of the Zentrum Paul Klee is to systematically open up Paul Klee's artistic, educational, and theoretical work and its significance in the cultural and social context of its time, and to present this significance in a clearly accessible form to visitors.

With questioning from today's perspective, with new academic interpretations and innovative presentation methods, the Zentrum Paul Klee aims to introduce the creative potential of Paul Klee as an impulse for the artistic and cultural present.

For visitors, Klee is to become more accessible. They should be able to experience Klee in a way that allows them to confront his work and encourage them to return to the Zentrum Paul Klee. With its activities, the Zentrum Paul Klee establishes itself as the world's premier center of competence in research and information on the life and work of Paul Klee and the effects they had.

In order to achieve these aims, in 2003 the Zentrum Paul Klee developed a broad spectrum of exhibition and information programs suited to the needs of visitors of all ages, backgrounds, and cultural interests.

To that end,

l exhibition rooms of high aesthetic and functional quality are available for a changing presentation of works from the collection and for special exhibitions

l the communication zone offers a large number of electronic and printed information

l a large activities area encourages children, teenagers, and adults to unfold their own creativity

l specially designed rooms allow interested visitors to take a look at parts of the large collection of drawings

l a chamber music hall offers a perfect opportunity for a musical experience

l modern multi-purpose- and seminar rooms with state-of-the-art equipment allow the discussion of topics from different areas of culture and science

l the surroundings, designed by architect Renzo Piano, and the Sculpture Park offer a unique symbiosis of nature and culture

The Zentrum Paul Klee has created the foundations for the realization of its exhibition and information program by

l developing and applying attractive informative and presentation methods

l carrying out research which broadens knowledge of Klee's artistic environment and the effects his work had, as well as making the results of this knowledge accessible to the wider public

l expanding on certain areas of the collection, taking into account Paul Klee's circle of artist friends

l ensuring the proper conservation and restoration measures are taken with respect to the collection

| keeping up exchange programs with art museums worldwide
| cooperating with museums and other cultural and educational institutions at the city, cantonal, and national level.

The Klee and Müller founding families, the public authorities, and the people of the city, canton, and Burgergemeinde Bern, as well as the center's commercial partners have made the Zentrum Paul Klee possible.

Form and Function

The architecture creates the functional and aesthetic framework, thereby setting the scope of the center's future possibilities. The spatial and architectural qualities of the Zentrum Paul Klee had to fulfill the demand of making it possible to bring to life the idea behind the center and keeping it alive. Renzo Piano dealt extensively with the question of which architecture, which topography, would best match the spirit and the work of Paul Klee. At the same time, he had to meet the expectations of the Maurice E. and Martha Müller Foundation—whose schedule of the use of the space was considerably expanded. The brilliance of Renzo Piano's architecture is not only in its remarkable geometry, but equally in the manner in which he has created the necessary architectural framework for a multifunctional enterprise.

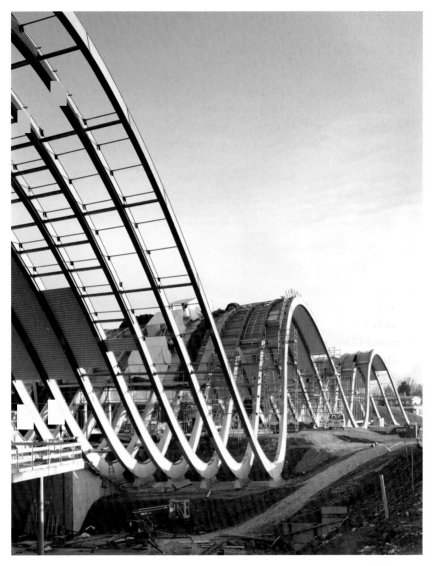

The sine wave architecture of the steel supports of the Zentrum Paul Klee, 2004

Monument im Fruchtland

Benedikt Loderer

Renzo Piano loses no opportunity to remind people that he is the son of a master builder—which may have given him his love of the trade. "I used to go to building sites with my father when I was little, I was fascinated by seeing how things were created from nothing by the hand of man alone. [...] I have had the great good luck of being able to spend my life doing what I dreamed of as a child." For Piano, it is obvious that, given the father he had, he could go no other way in life.

From time to time, he compares himself to Robinson Crusoe, a man who knew how to survive on unknown terrain using practical intelligence. The architecture critic Kenneth Frampton summed it up thus: "During his entire career, Piano has worked towards a myth-free architecture, with one exception: the myth of the inborn, world-creating primeval urge of a Homo Faber."

Born in Genoa in 1937, Piano studied architecture in Florence and Milan. Ernesto Rogers and Giancarlo De Carlo were his most important teachers and role models. He calls Richard Buckminster Fuller, Pier Luigi Nervi, and Jean Prouvé his "distant teachers." After completing his diploma in 1964 at the Milan polytechnic, Piano began to experiment. He operated with tension and pressure, built big things out of nothing, developed filigree constructions out of rods, cables, and membranes; he introduced shells of the new material polyester into his buildings, put together spatial structures out of prefabricated pieces. His goal is lightness. The constructions themselves must be light, but so must the game of discovering them. Renzo Piano is never heavy-handed.

Working jointly with his business partner Richard Rogers, he won the international competition with his design for the Centre Pompidou in Paris, which was completed in 1978. With that city machine, Piano made his entrance onto the stage of international architecture, and has been one of the world's great architects ever since.

The Design Machine

When Renzo Piano won the Pritzker Prize, the Nobel prize of architecture, in 1998 he said in his acceptance speech "That is why I see in it [architecture] above all the curiosity, the social expectation, the lust for adventure—they are the motives which have kept me away from the temple." The opposite of the temple is the workshop. Piano calls his the Renzo Piano Building Workshop, and it is a laboratory for ideas and experiments. There are in fact two workshops—one in Genoa

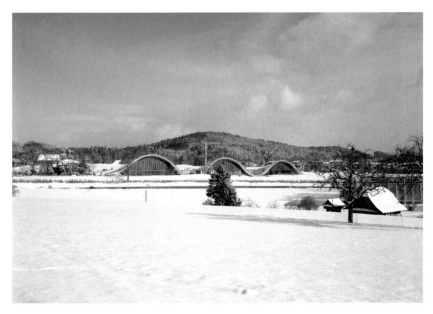

The Zentrum Paul Klee, seen from the west, 2004

and one in Paris. The Paris one is located in the middle of town on the Rue des Archives. Its picture window guarantees passersby a view of the model-building workshop, which is par for the course with Piano. Models — in fact, hand crafting of all kinds — are a vital part of Renzo Piano's design methods. Architects rely on seeing and feeling. They have to touch what they see, and they have to make visible what they visualize. The Building Workshop is a buzzing hive, stuffed full of models, presentations, books, and computers, inhabited by around thirty lively people.

Calculation and work. Trial and error, first on paper, then as a model, then eventually as a prototype on a scale of one to one, that is the method of the practical scientist Renzo Piano and his people. The design process oscillates between tinkering and totaling, the simplest hand-drawn sketches and the most hi-tech computer drawings are used. It is a fascinating mixture of playfulness and calculated precision. The search party takes side turnings, longer routes, gets itself out of dead ends, but every step takes them closer to an as yet undefined goal. The detours are necessary — they ensure that no short circuits, no apparent short cuts, lead to a rash, un-thought-out result. Anyone who commits himself too soon, locks himself in. Piano's people approach their task like a team of researchers on thin ice. The model is not there to impress, it is an instrument of discovery. The Workshop is an intellectual powerhouse. Piano summarizes as follows: "In architecture, everything mixes and everything contradicts. But contradictions are the salt of life. Take

Three hills as an integral part of the landscape, the Zentrum Paul Klee seen from the northeast, 2004

the opposites of art and science. For me, they are two dimensions which are not mutually exclusive, rather, they exist parallel to each other. Architecture is an art and a science. Without science, you can't make art, that is clear. We have quite a lot of experience of that in our team. We have so much knowledge that we are sometimes able to forget about it, like a good pianist who no longer has to think about his technique and loses himself in his playing."

The Hill

Maurice E. Müller saw the Beyeler Museum in Riehen near Basel—and that convinced him of Piano's talent. He commissioned him with the construction of a monographic museum for Paul Klee. Piano reacted as Piano does. As they stood at the site for the first time, Maurice E. Müller, Renzo Piano, and Bernhard Plattner, the project director, all realized that they could not accommodate Klee in any "normal building." They agreed that one needs time for Klee—and then there was this hill which they photographed straight away. It was not a very tall hill, but it was a very attractive hill. And of course, they took in the full effect of the autobahn which cut through the landscape. In this semi-rural setting, the noise of the highway made it obvious where they were: amid the agglomeration of Bern at the end of the twentieth century.

What Piano saw, experienced, and felt, in the grounds at Schöngrün in the winter of 1998, he summarized shortly thereafter in a letter to Maurice E. Müller: "Where

to begin? With Paul Klee, of course. It is the dimension of calm which best suits this artist. A poet of calm ought to make one think about a museum of a fundamentally quiet nature."

Castrum Lunatum

Where there are no hills, one must make them. Piano constructed a building and created a landscape around it. The artifact and tamed nature balance each other on the scales. The hills are two things at the same time: they are literally creations of art and a manipulation of the land. They are the museum's very trademark which engraves itself on the memory. In accordance with that, the graphic abbreviation of the threefold wave became the logo of the Zentrum Paul Klee. Seen from the autobahn, the three curves of the roof appear for ten seconds—an unexpected shape heralding the out of the ordinary. Seen from the park, the three mysterious waves give the observer a feeling of uncertainty. What is being camouflaged here? Piano believes in a secret link between imagination and landscape; it creates the aura of naturalness in the artificial. Looking at the model, one is reminded of a crescent-shaped fortress, a sunken *castrum lunatum,* set in a step in the level which follows the line of the old city wall. The autobahn is the moat, the inclined façade the remains of the castle. Only a small part of the bulk of the building shows above the surface—what counts is dug in, keeping its head down so as not to present a target. "We are building a house for Paul Klee, but a building is a building and not a work by Paul Klee," warns Piano. The architect is not the mere servant of art. He places himself alongside Klee and not in his shadow. Piano's architecture does not aim to be neutral. The work of art remains independent, regardless of whether it is the work of the painter or the architect.

The Functionalist

The project is frankly functionalist as far as its inner organization goes. There is no sentimental green suggestion that this is the womb of mother Earth; this is the realization of a high-tech construction which has been welded together, not stitched. There is no geometric game with sharp angles and sloping walls—Piano builds right-angled spaces which fulfill their function.

What do today's museums suffer from? Their overwhelming success. Therefore, they must build for success—and that means for large crowds of visitors. But what is the primary duty of a museum? Protecting, displaying, researching. Piano solves the contradiction of spectacle and contemplation with his ground plan, which divides up the public areas into different zones. The more noisy and public a function is, the closer it is located to the glass wall on the autobahn side; the quieter it is, the further into the depths of the building it can take place. The depth of the building becomes a filter. The roughly 150-meter-long Museum Street, the curved

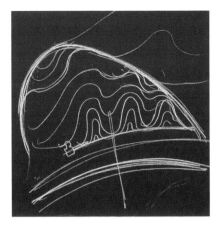
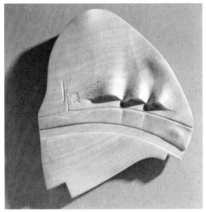

Sketch by Renzo Piano showing the topography of the landscape sculpture

Solid wood model of the landscape sculpture

corridor, is located at the periphery and connects all the public areas. In the middle zone, set back from the Museum Street, there are exhibition rooms, the conference and music halls, and the offices. Behind them are the staff-only areas, the work-shops, and the stacks. At the very back, in the very innermost part, there is another corridor, closed to the public, which links up these areas.

Each of the three hills has its own function. The North Hill is for the practical com-munication of art, music, conferences, and the workshops; the Middle Hill is for the exhibition of the collection and temporary exhibitions, while the southern hill is for research and administration. In summary, it is a rational, functional ground plan.

The building itself is solid and avant-garde at the same time. It is solid because it is meant to last a long time, avant-garde because of its construction. Considerations of how to build it began with the image of ribs, the transverse ribs of a ship's keel. How else and of what should the wavelike supports be made? Wood? Concrete? Steel? The search ended with steel. Every arch is different, of varied height, and was cut out of steel plates with a gas cutting machine, stamped into its final shape, and—because of the high degree of curvature—welded together by hand. The welders put more than forty kilometers of welds into this building.

The wave form had to be chosen so that the dimensions of the construction ele-ments could be calculated. On the ground plan, the façade stands in an arc with a radius of 460 meters. A cross-section reveals it as a conic section whose mantle wall has a slope of nine degrees. The waves are shaped like a sinus curve. The pressed-down backs of the hills form the outside of a cylinder. The computer made it all possible. The big 3-D model on the computer was the basis for determining the shape, measurements, and means of producing the individual pieces. One only

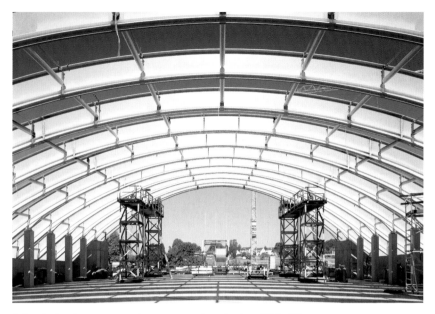

Before the façade was completed, there was a unique view from Middle Hill
(now exhibition space for the collection), 2004

need imagine the façade as a straight front instead of a curved one to be able to imagine what a spectrum of new expression the computer allows. Piano has always been quick to understand and apply new technologies to make architecture.

The Glass Wall

The unusual geometry of the building required the difficult construction of a 150-meter-long glass façade. It is divided into an upper and a lower section along its entire length. Both parts are set down by the same distance as the Museum Street is wide, and are linked by the cover of the roof of the Museum Street—at a height of four meters. At its highest point, the façade is nineteen meters high, and the largest panes of glass measure 6 by 1.6 meters and weigh 500 kilograms. The façade is suspended from four of the roof supports so it can adjust to compensate for deformation that comes about as a result of pressure from the wind and extremes of temperature. The construction of the roof and the façade is not stiff, it has a degree of freedom to move. It has the advantage of allowing the Museum Street to be free of supports.

With the façade, Piano once more demonstrated his mastery of detail. He reveals the layers piled up on top of one another, celebrates the tension-bearing cables, fastening elements, support bases, and makes the flow of forces visible, demonstrating their mechanics. The visitor is aware of Piano the architect-engineer and engineer-architect—and his passion. For Piano, perfection is not omission, it is

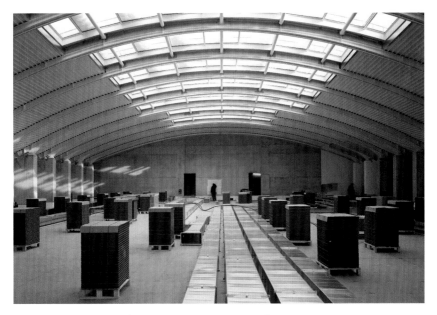

South Hill under construction (today Research and Administration), 2004

demonstration. German-Swiss minimalism is not his thing; he displays the individual pieces and the coordinated workings of his façade machine. This façade gives the building a clear front and back. There is a preferred view—one looks toward the city, toward Bern.

The Mood

The mood is what tips the balance. Piano and his people know how to create a mood: with space and light. The Building Workshop spent a long time in intense consideration of the direction of the light and the illumination of the rooms. But there is little point in comparing this with the Fondation Beyeler Museum, although such a comparison at first seems obvious. Klee's works, mostly watercolors, may be exposed to a light intensity of 50 to 100 lux at most, otherwise they will fade. The paintings in the Beyeler Museum can stand 240 lux. In comparison with the light machine in Basel, it is twilight in Bern. The result of that is artificial light. The main hall in the Middle Hill is lit purely by artificial light. The basic lighting was installed in the roof supports, and it shines indirectly into the room via the ceiling. The paintings are illuminated by small spotlights.

Gauze has been stretched out over the dividing walls—light shines through it but one cannot look through it. The visitor is meant to perceive the exhibition hall as a single room, while at the same time experiencing a strong intimacy with the paintings. The dividing up of the rooms with screens is only done using linear elements

which do not touch the walls. The room is meant to flow unhindered and not be interrupted by cabinets. This underlines the fact that the screens are set a hand-breadth above the floor. An oak parquet floor has been put down throughout the museum. The walls are of white plaster, the ceiling is of white-painted, overlapping panels. Klee's work is displayed in a quiet, cheerful, spacious, and dignified hall. Under the southern hill, a large skylight illuminates the hall set out as an open-plan office; in the northern hill, the light comes in through an air well. In both cases, an unspectacular device is very effective in bringing in the light. The Museum Street behind the glass wall is very brightly lit by natural light. Large-area shading elements outside the western façade prevent the sun from shining straight in.

The Closed Climate

Today's museum is a closed climate. It is twenty-three degrees in summer and twenty-one degrees in winter. The permitted deviation is one degree Celsius. The humidity is stable, fifty percent, with a permitted deviation of 5 percent. These are the conditions that museums and their insurers require. Questioning them means no works will be lent to you. That the entire building is very well insulated goes without saying. And, of course, the heating works with a heat recovery function. The building's annual energy consumption will be low in comparison with that of other museums.

Klee painted a watercolor with the title *Monument im Fruchtland (Monument in the Fertile Country)* (fig. p. 53), and that is now the address of the Zentrum Paul Klee: Monument im Fruchtland 3, 3006 Bern.

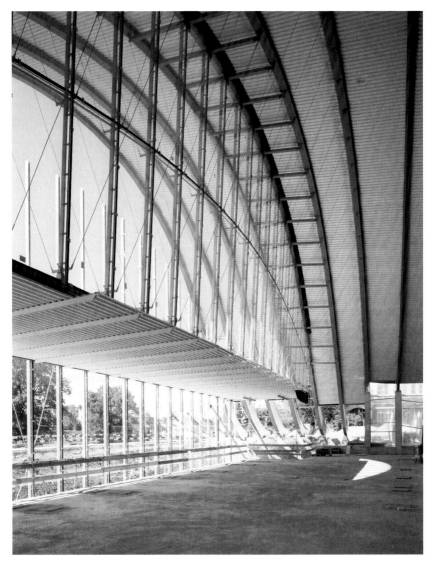

Construction of the façade from the inside, North Hill, 2004

Paul Klee: Biography

Michael Baumgartner

1879

Paul Klee is born in Münchenbuchsee near Bern on December 18, the second child of Hans Klee (1849–1940) and Ida Klee (1855–1921), née Frick. His sister Mathilde (died 1953) was born three years earlier. His father is a music teacher at the Staatliches Lehrerseminar (state teachers' seminar) in Hofwil, near Bern, his mother a trained singer.

1880

The family moves to Bern. The boy receives his first lessons in drawing and coloring from his grandmother, Anna Catharina Rosina Frick, née Riedtmann.

1886–1897

Klee attends primary school in Bern. He obtains his secondary education in the humanities program at the schoolhouse of what was later the Progymnasium (middle school) on Waisenhausplatz. He fills his schoolbooks and notebooks with caricatures, copies images from magazines and calendars, and draws objects from nature. For Klee, the final years of school are a trial: "I would have liked to run away before my eleventh-grade exams, but my parents stopped me." The newspaper *Die Wanze* (The Bug), which he and two friends produced for the last year of middle school, causes a scandal at the school.

The resolve to become an artist is growing in Klee even during his school years. He spends a long time wondering whether to become a musician or a painter.

Paul Klee (right) with his sister Mathilde and their uncle Ernst Frick, Bern, 1886

Paul Klee, Bern, 1896

1898

Klee starts keeping a diary; the first entry is dated April 24. He finishes his secondary education with a *Matura* at the Städtische Literarschule (literary secondary school) in September. Just one month later, on October 13, he moves into an apartment in Munich, where he attends the private drawing school run by Heinrich Knirr. From the autumn of 1900, he also studies under Franz von Stuck at the Academy.

1899

Klee meets the pianist Lily Stumpf (1876–1946) at a musical soirée.

1901

He leaves von Stuck's painting class. On October 22, Klee and the Bern sculptor Hermann Haller leave for a six-month period of study in Italy. Klee travels to Rome via Genoa and Livorno, and rents a room in the capital.
The overwhelming richness of Rome's classical art plunges Klee into an artistic crisis.

1902

Klee becomes engaged to Lily Stumpf. He lives with his parents in Bern for the next four years, unable to secure an independent living from his art. His primary sources of income at this time are engagements as a violinist at the Bernische Musikgesellschaft (Bern Music Society). Klee regards this period at his parents' home as an opportunity to find himself and to mature.

Hermann Haller and Paul Klee on a bridge over the Tiber in Rome,
February 1902

1905

Klee travels to Paris for two weeks with Hans Bloesch and Louis Moilliet, friends
he has known since the days of his youth in Bern.

1906

Klee spends two weeks in Berlin during April. On September 15, he marries
Lily Stumpf in Bern. Two weeks later, the couple moves to Munich.

1907

Felix Paul Klee born on November 30, the son and only child of Paul and
Lily Klee.

1909

Felix becomes grievously ill in the spring; Paul Klee takes on the task of caring for
the child. The family spends the summer holidays this year, as in the following
years until 1915, in Bern and the surrounding area, particularly on Lake Thun. In
November, Klee has the idea of illustrating Voltaire's *Candide*. The drawings are
not executed, however, until 1911.

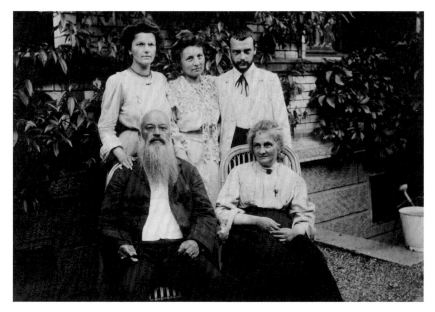

The Klee family in their garden at Obstbergweg 6, Bern, September 1906.
Top row, left to right: Klee's sister Mathilde, wife Lily Klee-Stumpf, Paul Klee;
bottom row: Klee's father, Hans Klee, and his mother, Ida Klee

1910

Klee has his first solo exhibition in July. Comprising fifty-six works, the exhibition starts at the Bern Kunstmuseum and moves on to the Kunsthaus in Zürich, the Kunsthandlung zum Hohen Haus in Winterthur, and the Kunsthalle in Basel.

1911

In February, Klee begins to compile a handwritten catalogue of his works. From this point until just before his death, he keeps a painstaking record of his artistic production.

In autumn, Louis Moilliet arranges for Klee to meet his fellow artist Wassily Kandinsky. Klee becomes familiar with the aims of the Blauer Reiter group. In the Swiss monthly *Die Alpen,* edited by his old friend Hans Bloesch, Klee publishes reviews of exhibitions and cultural events in Munich.

1912

Franz Marc and Wassily Kandinsky invite Klee to take part in the second Blauer Reiter (Blue Rider) exhibition at Hans Goltz's bookshop in Munich. Seventeen of his works go on show. In April, he travels to Paris for a second time and visits the artists Robert Delaunay, Henri Le Fauconnier, and Karl Hofer in their studios.

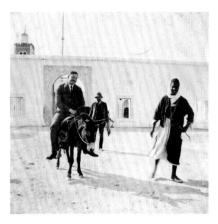

Paul Klee and August Macke,
Kairouan, April 1914

1914

Klee travels to Tunisia at Easter with his artist friends August Macke and Louis
Moilliet. The trip takes him via Marseille to Tunis, St. Germain, Hammamet,
and Kairouan. After his return, Klee holds a joint exhibition with Marc Chagall in
Herwarth Walden's Galerie Der Sturm in Berlin; in October he presents his latest
aquarelles, painted in Tunisia, within the framework of the Neue Münchner Sezes-
sion artists' movement, of which he is a founding member. The assassination of the
heir to the throne of the Austro-Hungarian empire in Sarajevo on June 28 leads
to the outbreak of the First World War. On September 26, 1914, Macke is killed in
action near Perthe-les-Hurlus in Champagne.

1915

Klee has a chance meeting with the poet Rainer Maria Rilke in Munich. He spends
the summer in Bern; on his return journey to Munich, he goes to Goldach on
Lake Constance to visit Kandinsky, who, as a Russian national, has had to leave
Germany following the outbreak of war.

1916

On March 4, Klee's friend Marc is killed at the front near Verdun. Klee is deeply
grieved. On March 11, he is himself drafted into the German army as a soldier.
He is first sent to the recruiting depot in Landshut. On July 20, he is attached
to the second reserve infantry in Munich, then transferred in August to the mainte-
nance company of the air corps in Schleissheim. From there he accompanies
planes that are transported on the ground to Cologne, Brussels, and Nordholz in
northern Germany.

Paul Klee with his fellow soldiers during
the First World War, Landshut, 1916

1917

In January Klee is transferred to the Royal Bavarian Flying School V in Gersthofen
where he is a clerk in the finance department. His joint exhibition with Georg
Muche at the gallery Der Sturm in February is a commercial success.

1918

Klee is sent on leave until his demobilization in February 1919. He stops keeping a
diary and never goes back to it. But in the years to follow, Klee does rework and
edit his diaries, turning them into his autobiography.

1919

After being released from military service, Klee rents a studio in the Suresnes
Schlösschen in Werneckstrasse in Munich. During the postwar Bavarian soviet re-
public he becomes a member of the Munich council of fine artists and of the activist
committee of revolutionary artists. Oskar Schlemmer and Willi Baumeister try
unsuccessfully to have Klee admitted to the Stuttgart Academy. On October 1, Klee
signs a general agency contract with Hans Goltz, owner of the Galerie Neue Kunst-
Hans Goltz in Munich.

1920

From May to June, Hans Goltz puts on the biggest Klee exhibition to date in his
gallery, a retrospective with 362 works. On October 29, Walter Gropius calls Klee
to the Staatliches Bauhaus in Weimar. Klee's first fundamental essay on the theory
of art appears in Kasimir Edschmid's anthology *Schöpferische Konfession* (Creative
Confession). Leopold Zahn and Hans von Wedderkop publish the first mono-
graphs on Klee.

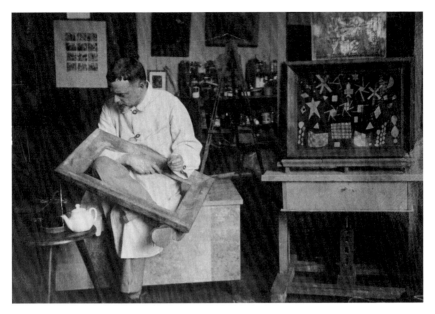

Paul Klee in his studio at the Bauhaus Weimar, 1924

1921

In March, Wilhelm Hausenstein's monograph *Kairuan oder eine Geschichte vom Maler Klee und von der Kunst dieses Zeitalters* is published — the most important book up to that point on Klee as an artist. On May 13, Klee commences his academic teaching career at the Bauhaus with a course in "practical composition." As master of form, he is head of the workshop for book binding.

1922

Klee takes over the artistic direction of the gold-silver-copper smithy from Johannes Itten, then in the autumn exchanges it with Oskar Schlemmer for the latter's workshop for glass painting.

1923

Klee's essay "Wege des Naturstudiums" (Ways of Nature Study) appears in the publication on the weekly events in the Bauhaus.

1924

The first Klee exhibition in the United States takes place from January 7 to February 7, organized by Katherine S. Dreier of the Société Anonyme, New York. The artists' group Blaue Vier (Blue Four) is founded on March 31 on the initiative of Emmy (Galka) Scheyer. The Blaue Vier's works are exhibited primarily in

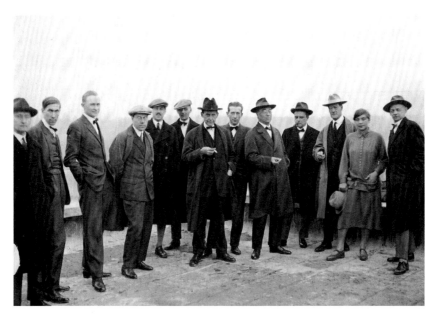

Bauhaus masters on the roof of the Prellerhaus, Bauhaus Dessau, 1926. Left to right: Josef Albers, Hinnerk Scheper, Georg Muche, László Moholy-Nagy, Herbert Bayer, Joost Schmidt, Walter Gropius, Marcel Breuer, Wassily Kandinsky, Paul Klee, Lyonel Feininger, Gunta Stölzl, Oskar Schlemmer

the U.S. Along with Klee, the group is made up of Lyonel Feininger, Wassily Kandinsky, and Alexei Jawlensky. In September and October, Klee and his wife spend time in Italy, particularly in Sicily. On December 26, the leading members of the Bauhaus submit to enormous political pressure and declare the school in Weimar will be closed in April the following year.

1925

In March the council of Dessau decides to invite the Bauhaus to move to the town. Klee's *Pädagogisches Skizzenbuch* (Pedagogical Sketchbook) appears in October as the second volume of a series of Bauhaus books published by Walter Gropius and László Moholy-Nagy. Klee cancels his agency contract with Hans Goltz and consequently increases his business contacts with Alfred Flechtheim, the owner of two galleries of the same name in Berlin and Düsseldorf. Klee's first exhibition in France runs from October 21 to November 11 in the Paris Vavin-Raspail gallery. In November, some of his pictures are shown at the first Surrealist exhibition at the Galerie Pierre in Paris.

1926

Klee and his family move to Dessau on July 10. There they live with Wassily and Nina Kandinsky in one of the three duplexes built by Gropius for Bauhaus master craftsmen.

1927

Starting in April, Klee teaches the Bauhaus's Free Workshop Painting, also known as the Free Painting class. From October, he teaches design for weavers. In the late summer, he travels to Porquerolles and Corsica.

1928

Klee publishes the essay "exakte versuche im bereich der kunst" (precise experiments in the field of art) in the magazine *Bauhaus* in February. Hannes Meyer becomes the new Bauhaus director. On December 17, Klee begins a four-week trip to Egypt, paid for by the Klee Society, a group of collectors founded by Braunschweig collector Otto Ralfs in 1925 with the aim of supporting Paul Klee.

1929

Klee and his wife spend their summer holidays in France and Spain. Klee begins negotiating with the Staatliche Kunstakademie Düsseldorf on the prospect of obtaining a professorship. He is at the pinnacle of his success and is regarded as one of Germany's most internationally respected artists. The Museum of Modern Art in New York, the Nationalgalerie, and the Galerie Alfred Flechtheim in Berlin organize major exhibitions for Klee's fiftieth birthday.

1931

Klee takes up his professorship at the Düsseldorf Academy on July 1. He rents a room in Düsseldorf, but keeps his apartment in Dessau until April 1933. He and Lily go to Sicily in the summer.

1932

Following an application by the National Socialists, the Dessau council votes to close down the Bauhaus.

1933

The National Socialists take power across Germany in January. In mid-March, Klee's apartment in Dessau is searched. On April 21, Klee is suspended from his position as a Professor at the Düsseldorf Academy; under the law for the restoration of the professional civil service, Klee is officially dismissed as of January 1, 1934. On October 24, he signs a sole agent contract with Daniel-Henry Kahnweiler,

Paul and Felix Klee on the balcony of the apartment at Kistlerweg 6 in Bern, 1934

the owner of the Paris Galerie Simon. On December 24, Klee emigrates to Switzer-
land—as his wife had done two days before—initially living in his parental home
in Bern.

1934

In January, Paul and Lily Klee move into a small apartment at Kollerweg 6, moving
again on June 1 to a three-room apartment at Kistlerweg 6. The monograph
Paul Klee: Handzeichnungen 1921–1930 by Will Grohmann appears in November.
Its publisher is in Potsdam; the company is seized by the National Socialists in
April the following year.

1935

In August Klee contracts bronchitis, which develops into pneumonia. In November
he falls ill again; the illness is diagnosed as measles. Klee is largely confined to
his bed.

1936

Continuing poor health means that Klee is forced to stop work for about half
a year, and even after that he is unable to get much done. His output for the year
is just twenty-five works—an all-time low.

1937

Klee's health stabilizes, and he is once more able to work more intensely. On July 19, the exhibition "Degenerate Art" (Entartete Kunst) opens in Munich. In slightly reduced form, it runs until 1941 as a traveling exhibition and is shown in twelve other German and "Austrian" cities. It contains seventeen of Klee's works. The National Socialists seize 102 of Klee's works from public collections and sell most of them abroad.

Pablo Picasso visits Klee on November 27. In 1937, Klee produces 264 works—nearly as many as in the years before his illness.

1938

From this year on, gallery owner J. B. Neumann and two art dealers who had emigrated from Germany, Karl Nierendorf and Curt Valentin, organize regular Klee exhibitions in New York and other cities in the United States.

1939

In April Georges Braque twice visits Klee in Bern. On April 24, Klee applies for Swiss citizenship. With 1,253 registered works—most of them drawings—1939 is Klee's most productive year ever.

1940

Klee's father Hans dies on January 12. In May, Klee goes to the southern Swiss canton of Tessin for a period of convalescence. His state of health deteriorates suddenly in June. He dies on June 29 in the Clinica Sant' Agnese in Locarno-Muralto, just days before he would have received Swiss citizenship.

Paul Klee in his studio at Kistlerweg 6 in Bern, July 1939

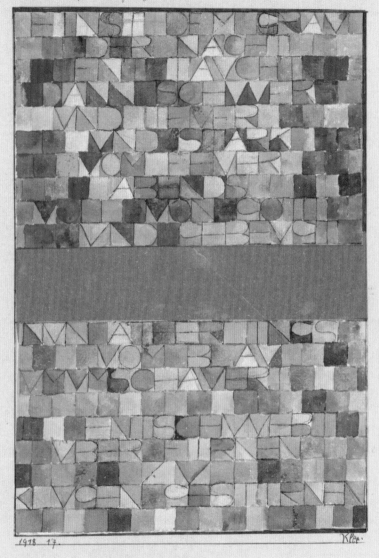

Einst dem Grau der Nacht enttaucht . . . , 1918, 17
Once Emerged from the Gray of Night . . .
Watercolor, pen, and pencil on cut up paper,
on cardboard
22.6 x 15.8 cm
Zentrum Paul Klee, Bern

The View of Klee

Tilman Osterwold

New rooms open up a fresh outlook on the work of the artist who, approximately a hundred years ago, began using paintings, drawings, and writings to examine the way he saw himself artistically. In this setting with its three hills, designed by Renzo Piano for the Zentrum Paul Klee, the Middle Hill is dedicated to Paul Klee as an artistic personality. It is an architecture which focuses on our awareness of artistic content and which has an inspirational effect on the ways art conveys itself. The works of Paul Klee have found a new home here—a retrospective which looks to the future, and which aims to bring into the present day this unusually complex, thoughtful, playful artist who wanted to illuminate everything in the world. This view of things makes it all the more exciting to examine certain aspects of Paul Klee's work from a fresh perspective and—incorporating the innovative possibilities of architecture—to present them with an awareness relevant to our time. The presentation of his work follows the maxim: open up the vista of the artistic substance, onto the physiognomy of the paintings, onto the human levels which the works project onto the observer, onto the modernity of their composition which tears up the conventional spectrum of perception and breaks up the expected patterns of taste, onto the interdisciplinary complexity of the theoretical alignment of the works—which was unique in Klee's time and is completely up to date even from today's perspective.

The opening up of this fresh perspective begins with an architectural introduction, associating clear views and open spaces. The path into the world of Paul Klee has been set out programmatically. The paintings are placed into a dialogue with one another, not necessarily in chronological order, so as to bring out the complex levels of expression in Klee's work. To do that, one must explain some of the characteristics which have a special metaphorical meaning for Klee and which, seen over and over in fresh contexts, are at the heart of his compositional confrontation with the creative processes:

l The human and natural essences motivate the artistic principle. Nature, growth, and motion form the image of the creative, for the genesis of the picture. The cosmos and the universe, microcosmically and macrocosmically, contain the entirety of the human individual and the natural context.

l The stage becomes a visual metaphor for the artistic. Klee invents scenarios which take as their subject the form and content dimensions of balance and their irritations. The theatrical staging of his paintings make Klee's ambivalent attitude toward the comic and the tragic "dramatically" clear.

| Architecture and topography are metaphors for the structure and the composition of an image—and may also be applied to possible approaches.

| Music and musicality are basic elements in Klee's artistic thinking; a formal principle which contains motion and rhythm as well as the simultaneous effect of compositional elements as the central components in the creation of a picture *(Garten=rhythmus [Garden Rhythm]* 1932, 185, fig. p. 93).

| Childhood is an existential basic element in Klee's consciousness of a balanced relationship between originality and professionalism, simplicity and calculation, the creative drive and the intellect.

| Klee interprets the facial expression, the view from the outside into the inside, as the physiognomy of a painting. In his theoretical writings, he analyzed the time-limited functions of perception with this in mind, and he also transferred this experience into his compositions *(Blick aus Rot [Glance out of Red]*, 1937, 211, fig. p. 47).

The first important high point in Klee's creative life came about in 1919 with the landscape compositions which were, at the same time, a guided tour through the complex field of artistic means of expression: *"Felsenlandschaft" (m/Palmen und Tannen) ("Rocky Landscape" [With Palms and Fir Trees])*, 1919, 155, fig. p. 48, and *Komposition mit Fenstern (Composition with Windows)*, 1919, 156, fig. p. 72. The admixture of architecture, landscape elements, plants, of letters and abstract spaces follows a systematic method of composition: an additive arrangement in the construction of the picture, in whose irregular system the differing elements combine naturally.

In the 1920s he created a series of free abstractions, whose right-angled, constructive structure of mosaic-like colored surfaces takes a contrasting, completely opposite direction from the constructivism of the day—the structure is fragile, imprecise, shaking, yet balanced and counterbalanced at the same time. The surfaces appear to vibrate in their mutually shared space, to be in a state of latent movement. This sequence of tight, non-representational compositions is centrally placed in the exhibition. The intellectual proximity to the Bauhaus and to Klee's educationally-oriented theoretical work is very clear (see fig. pp. 78–79).

In Klee's pointillist compositions—which came into being around 1932 in Düsseldorf, where he held a professorship of painting—he refines the process of dividing up the entirety of the surface of the picture into a patchwork of countless varied individual pieces, all modified in their nuances of color and form (see fig. pp. 82–83). Paul Klee's unorthodox manner of creating spaces and of arranging rhythms and processes of motion in his paintings grew out of his thoughts on topography and his observation of communicative behaviors which occur in spatial constellations. Gardens, parks, and landscapes are popular themes in Klee's work; but

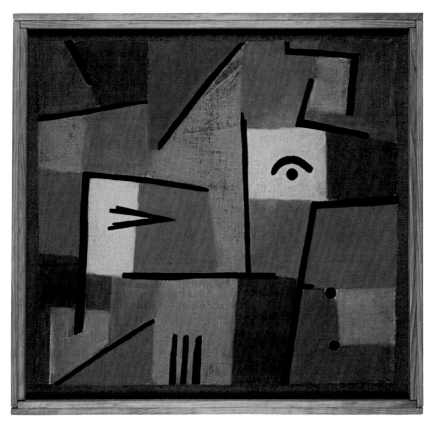

Blick aus Rot, 1937, 211 (U 11)
Glance out of Red
Pastel on cotton on colored paste on
burlap on stretcher;
reconstructed frame strips
47 x 50 cm
Zentrum Paul Klee, Bern, Livia Klee Donation

at the same time, they are metaphors for the imagery of his thoughts. The walk through the world of Klee's images offered by the exhibition is oriented along the lines of Klee's topographical philosophy. Thus, the constructive watercolor *Monument im Fruchtland (Monument in the Fertile Country)*, 1929, 41 (fig. p. 53), the title of which has been taken as the address for the Zentrum Paul Klee, provided an inspiration for the presentation of his work: a delicately-drawn, simplified landscape which draws life from the many different levels which have been superimposed and juxtaposed on the surface; these levels expand, set limits, open out, and close up, continually seeking a new, broader horizon.

"Sollte alles denn gewusst sein? Ach, ich glaube nein!" (Do I know all there is to know? I think the answer's no!) Paul Klee wrote these words—in fine pencil

"Felsenlandschaft" (m/Palmen und Tannen), 1919, 155
"Rocky landscape" (With Palms and Fir Trees)
Oil and pen on cardboard, nailed to a wooden frame;
original frame strips
41.8 x 51.4 cm
Zentrum Paul Klee, Bern, Livia Klee Donation

lines, underlined in white—in an incomplete symbolic composition begun in 1940, in which countless anonymous elements, drawn in colored paste and grease crayon on brown paper, appear to flow around without direction in an order of things seemingly driven by random impulses. Scriptural, symbolic elements are characteristic of Klee's later work. Every detail appears turbulent, changeable, continuable. This imagery combines with the diary-like nature of the drawings and paintings created quickly on paper, in which the artist expressively and obsessively tests the boundaries of labyrinthine and seemingly chaotic form. The panel paintings concentrate this journal-like work principle; they combine the quantitative wealth of his reflections in the uniqueness of a solitary work. In the panel painting *blaue Blume (Blue Flower)*, 1939, 555 (fig. p. 106) linear, brightly-colored, representational elements meld into a manifestation of the color blue (in homage to the Romantic period and Novalis's *"Blaue Blume."* Klee creates monochrome in many forms, many layers, many varying shades; blue becomes

an expression of a transcendental world *(Früchte auf Blau [Fruits on Blue],* 1938, 130, fig. p. 97).

The complexity of the color tones/tone colors and their manifold levels of meaning becomes communicable and perceivable in the chronological overview of Klee.

Paul Klee's Interdisciplinary Topography

"The formal must blend with the world view." Paul Klee noted this down in his diary for 1917 while he was stationed at Gersthofen outside Munich during the First World War. The historical perspective of this statement aims at a deeply philosophical basis for art, which is oriented toward a dialogue with the creative forces and toward a complex approach to reality. Klee describes art as an image of creation—"Art is set out like creation." Growth and genesis are concepts which link Klee's thoughts on art with motion as the decisive criterion of creative potential: art as an expression of the rhythm of motion of the creativity within human beings.

Klee's thoughts on art and creativity are reflected in many passages of text, as well as in pointedly formulated sentences in his diaries, letters, writings, and educational notes, which may be used to show noticeably deeper philosophical intentions in the thought and theory behind the artistic works. Klee describes art, makes art visible as a way for mankind to approach reality. The texts reveal the context in which he sets his art: it is the far-reaching complex of human coexistence, the endless permutations of meeting and moving, of individualization and commonalties, the "highways and byways" which meet up and separate—to cite a slight adaptation of the title of one of Klee's works—as well as bridges and crossroads, harmonies and disarrangements, balance and counterbalance.

Paul Klee sought an artist's approach to the complexity of his reality experience in the relevant "disciplines" as well as in their all-encompassing perspective. His *oeuvre* deals intensively with aspects of language, theater, and music. It encompasses architecture, technology, contemporary events, social themes, as well as mythology and the history of creation. It reflects on scientific, cosmic, physical, philosophical, psychological, even medical levels. Body language and "psychosomatic" constitutions of human individuals, as well as interpersonal dialogue, are brought into con-text as social phenomena. Klee researched and meditated on childhood, Eros, age, death, religiousness. Anthropological issues, an artistic interest in non-European cultures, interest in the images created by the mentally ill, (collection and publication by the physician Hans Prinzhorn, published 1922) were reflected in Paul Klee's paintings and drawings. In his educational writings and notes, Klee explained design complexes in terms of behavioral psychology, world view, evolution, music, and other contexts. This theoretical research, Klee's conclusions and teachings, are transformed into concrete images.

The artistic means of expression, thoughts reflecting his world view, and academic experience which were at the foundations of Paul Klee's artistic identity, reach across a broad spectrum of knowledge. In that, the interdisciplinary philosophy of the Zentrum Paul Klee corresponds with the interdisciplinary content of Klee's artistic philosophy.

Design criteria significant for the content are the levels of balance, the constructive importance of the plumb, the dialectics of stability and instability (fig. p. 104). In a visualization of his personal feeling, Klee once spoke of "the balancing of existence." Pictures such as *Der Seiltänzer (The Tightrope Walker)*, 1923, 121 (fig. p. 74) take up the complexity of instability and balance which Klee dealt with intensively at a theoretical level during his Bauhaus period. The balancing, creatively acting tightrope walkers and adventurers also appear as a metaphor for the artist himself, who, with his individual visual statements, opens himself up to an incalculable public, risking a confrontation of his "exotic" role as an artist with contemporary patterns of taste. Some pictures play directly upon the confrontation with the imponderables of balance *(Schwankendes Gleichgewicht [Unstable Equilibrium]*, 1922, 159, fig. p. 52; *Gewagt wägend [Daringly Unbalanced]*, 1930, 144).

Klee's ambivalent ideas on topographical motives form the basis of the interior design in which his work is presented at the Zentrum Paul Klee. "Let's develop, let's set out a topographical plan and make a little journey to the land of greater insight ..." Thus did Paul Klee begin the second chapter of his essay *Schöpferische Konfession* (Creative Confession), published in 1920—shortly before Klee's so important and ground-breaking time as a teacher at the Bauhaus in Weimar.

Paul Klee's artistic rhythm of movement, which combines improvisational and constructive forces, is strongly inspired by music and musicality, by acoustic phenomena. In this context, the relationship of image and language takes on a certain affinity with the relationship of music and language. The connection with poetry, with creative writing, is to be found in Klee's language of imagery.

Klee's visual poem *Einst dem Grau der Nacht enttaucht ... (Once Emerged from the Gray of Night ...)*, 1918, 17 (fig. p. 44) looks like a tableau in which an unorthodox and constructive color composition is combined with poetic language. Klee's literary gift also manifests itself in many of his authentic titles: Paul Klee underlaid the paintings and drawings listed in his *oeuvre* catalogue with a wealth of associative, interpretative points based in language.

Dimensions of Contemporary History

The nineteenth century forms the historical foundation of Paul Klee's human and artistic development. A social awareness of tradition as well as historical, romantic, and idealistic streams of thought formed the patterns of an aesthetic which pro-

tected itself with ethical and moral counterweights. These stabilizing factors were important in the Klee family's social environment. That was the backdrop for the cultural interests which helped to promote Klee's artistic development. Klee himself looked back on this issue in his reminiscences of childhood, and pointed out certain disciplinary measures and cultural preferences in his background in an understanding, thoughtful, and ironical manner. One major problem faced by Klee and other artists of his generation was the pressure of academic convention at art schools. Klee developed his studies in Munich. At the Heinrich Knirr studio he learned graphic modeling. During his time as a student under Franz von Stuck at the Akademie der Künste (Academy of Art) in Munich (1899–1901), which was interspersed with summer breaks in Bern, he painted his first landscapes, such as the large, five-paneled *Aarelandschaft (Aare Landscape)* around 1900 (fig. p. 60).

The years up to 1902/03—the real start to his artistic career—were characterized mainly by self-reflection and his immediate surroundings. His search for a new beginning, for creative substance rooted in simplicity, was unique in the art of the time and had considerable ramifications. For Klee, it was what drove him as an artist. He first spoke of it in 1901. In 1903 he regarded the series of *Invention* etchings (fig. p. 64) as his "completed opus I."

Following crucial meetings with Wassily Kandinsky, Alfred Kubin, and artist friends of the Blauer Reiter group around 1911/12, Klee did the *Candide* illustrations, taking up the themes of Voltaire's novel. The drawings represent the first high point of Klee's desire to "re-enter the primeval territory of psychological improvisation" (Diary 1908, 842). It was not until he experienced Tunisia that he found the key to color. "Color has me in its grip ... Color and I are one," he noted in Kairouan in 1914.

Paul Klee—son of a Swiss mother and a Bavarian father who was a music teacher in a town near Bern—grew up in the city of Bern. He was a German citizen all his life. During the First World War, he was drafted into the German reserves. A few drawings and works in color were made.

Klee wrote letters to his family and kept a journal, in which he outlined his skeptical, critical interpretation of the events of the time. He reflected on his personal feelings toward power, violence, war—and their effects on art. "I have had this war in me for a long time." (Diary 1915, 952). In words and in pictures, he cynically expressed his comments on the power structures, key political figures, and the instigators of the war *(Der grosse Kaiser zum Kampf gerüstet [The Great Emporor, Armed for Battle], 1921, 131).*

The end of the First World War, in which Paul Klee's friends August Macke and Franz Marc were killed, heralded in a period of new social and artistic development, in which the abstract, the individual, the emotional, the break with academic

Schwankendes Gleichgewicht, 1922, 159
Unstable Equilibrium
Watercolor and pencil on paper, framed in watercolor and pen, on cardboard
31.4 x 15.7/15.2 cm
Zentrum Paul Klee, Bern

Monument im Fruchtland, 1929, 41
Monument in the Fertile Country
Watercolor and pencil on paper, on cardboard
45.7 x 30.8 cm
Zentrum Paul Klee, Bern

traditions—also as an affront to the antiquated notion of what constituted art—were able to unfold and take effect. Klee's 1919 landscapes reflect this visionary energy, which moves from tragic experience back to his own carefree imagination *("Rocky landscape" [With Palms and Fir Trees],* 1919, 155, fig. p. 48).

During his Bauhaus time in Weimar and Dessau, Klee and his fellow artists developed the interdisciplinary concept of an artistic practice flowing into society. The events of contemporary history—war and violence—repeated themselves in a terrible way. The Nazi dictatorship eliminated society's creative potential, seized works of art, forced artists who were out of favor to stop painting, shut down the Bauhaus, and dismissed museum directors from their posts. The Nazi authorities suspended Paul Klee from his professorship at the Düsseldorf Kunstakademie (Academy of Art) in 1933. It was against this backdrop that the remarkable, small-format panel paintings were done, as observations on his own ego and the remains of his artistic *raison d'être,* broken by politics *(von der Liste gestrichen [Struck from the List],* 1933, 424, fig. p. 86). The density of these paintings—with which Klee sought to work his way out of his torment—is full of demonic feeling. He expresses his fears and the threats against him as mask-like, ghostly spheres *(Kopf eines Märtyrers [Head of a Martyr],* 1933, 280, fig. p. 86). They are visions of the terrible, reminiscent of childhood experiences—of nightmares, in which imagination and reality meet in an impenetrable intermediate world.

Klee left Germany for Switzerland, where he remained until his death in 1940. Here, he sought a new artistic beginning. He started "with a small orchestra"—as he put it in a letter to his friend, the art historian Will Grohmann—and worked relatively little. A look at his output in the years 1934 to 1936 reveals a Klee keen to experiment. He developed further variations on a decidedly informal painting style but the content remained bound to his memories.

In the final years of his life, Klee's artistic projections increasingly hark back to his own childhood. The reductive concept and the simplicity of his drawings—usually on notepaper or writing paper—follow the principle which Klee formulated early in his career: "Primitivity . . ." as "the ultimate professional discovery" (Diary 1909, 857). The high density, the internalized depth of the panel paintings in this period is incomparable.

Klee's later work—in particular that of the years 1938 to 1940—is characterized by a certain quantitative escalation in his work, above all, in his drawings. On January 2, 1940, he wrote to Will Grohmann: "The year was rich in pictures. I have never drawn so much, and never more intensely." "My production is taking on an increased dimension at a very increased pace and I can't keep up with these children. They arise . . . And twelve hundred in 1939 is a record," he wrote to his son Felix on December 29, 1939.

In May 1940, Paul Klee finished his *oeuvre* catalogue with the 366 numbered

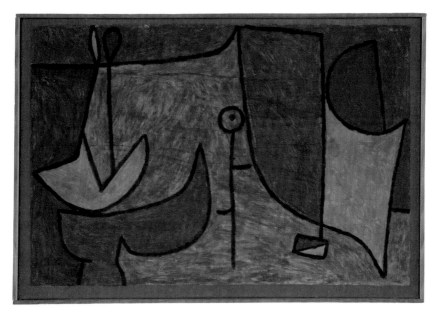

Stilleben am Schalttag, 1940, 233 (N 13)
Still Life on Leap Day
Color paste on paper on burlap
on stretcher;
original frame molding
74.6 x 110.3 cm
Zentrum Paul Klee, Bern

works of a complete year—a biographical criterion representing a fine conceptual point—namely, that the annual cycle becomes a symbol for the cyclical dimension of creative processes *(Stilleben am Schalttag [Still Life on Leap Day]*, 1940, 233, fig. p. 55).

Around 1940, Klee did a large-format panel painting which was found with his effects but which he did not integrate into his *oeuvre* catalogue. The picture is a completed work showing a still-life-like arrangement of objects of different origins *(Ohne Titel [Letztes Stillleben] [Untitled, Last Still Life]*, 1940, fig. p. 108). It has the appearance of a summary of his artistic thought. The composition is interspersed with symbolic figurines; on the table, an exotic sculpture and a coffeepot without a handle "rise." Sculptured, vase-like forms—with plant-insect ornamentation—are closely linked with three-dimensional foreign bodies at top left. The sun and moon are painted the way a child imagines these heavenly bodies. The transient, the material, is confronted with universality and eternity. There is no sign of any romanticizing or idealizing of the past, present, future! Laws of space and perspective appear to be lifted, rectilinearity shifted, balance thrown off, the familiar dismantled, clarity muddied.

Klee's *Engel, noch hässlich (Angel, Still Ugly)*, 1940, 26 represents an unstable, crooked position. Klee transformed the linear framework of the pencil drawing by painting it; giving full effect to the original lines using subtle gradations of color and three-dimensionally shaded structuring. The manner in which Klee transforms the objective and the fantastic into painting and combines them in a visual, compositional whole, his creationary balancing act between abstraction and reality, simplicity and alienation, recalls to mind a note in Paul Klee's diary in which he elaborates on his ideas: "Abstraction from this world is more than a game, less than a breakdown on this side" (Diary 1913, 922).

A "walk" through Paul Klee's work in Renzo Piano's museum building in Bern concludes with text pictures by the Swiss artist Rémy Zaugg (on the rear wall of the Middle Hill). They take up the theme of Klee's famous sentence: "Art does not reproduce the visible, it makes things visible." These are the opening words of Klee's 1920 essay *Schöpferische Konfession* (Creative Confession). It must be the most-quoted — and possibly inflated — statement by an artist of the Early Modern period. The idea that art is the domain of imitation is "timeless." But Klee and some of his contemporaries recognized that art invents realities, that art represents its own, eternally self-renewing reality. This world of art, fed by complex experience, initiates a dialogue between one human being and another. Our presen-

tation concept here tries to involve everyone in the liveliness of this inspiring process. Hand in hand with the guidance provided by the architecture, our concept aims to open up new perspectives on Klee, with a "stroll" through a world of pictures whose communicative energy turns the perception and the sensitivity of the observer himself into the subject of the exhibition.

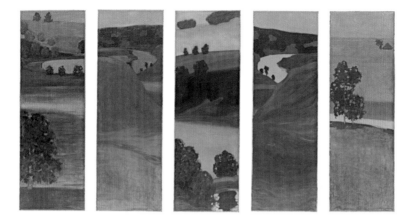

"All at once I was standing by the Aare; as if I had gone mad"

The five-paneled screen gives us a view of the Aare landscape outside Bern—a landscape Paul Klee loved above all others. The place was known to him from his early years—as a child, he often felt that adults misunderstood him, and sought sanctuary in the valley of the Aare. A series of technically extremely mature sketches and drawings by the seventeen-year-old were the fruit of this early, intense experience of nature and the landscape. *Die Aare bei der Hunzikenbrücke (The Aare at the Hunziken Bridge)* and *Aus der Elfenau (View from the Elfenau),* for instance, both done in 1896.

One of Klee's earliest ever oil paintings, *Aarelandschaft (Aare Landscape)* (fig.), was a commission carried out by the young artist during a three-month visit to Bern in the summer of 1900. Klee put his summer vacation from the Munich Kunstakademie (Art Academy)—where he had been studying under Franz von Stuck for six months—to good use, relaxing in his beloved countryside around Bern, and earning a little money with the odd commission.

In a letter to his future wife, Lily Stumpf, Klee made some disparaging remarks about the "indigestible folding screens" which he felt were keeping him from his true artistic work. It seems he disliked having to so obviously orient himself toward an Art Nouveau-style aesthetic of ornamental design and tonal color scheme in line with the popular taste of the times.

Today's assessment is rather more generous. The work is convincing in the very

Ohne Titel (Aarelandschaft), ca. 1900
Untitled (Aare Landscape)
Oil on canvas, originally on stretcher,
five-panel screen
Each screen 144.5 x 48 cm
Zentrum Paul Klee, Bern, private loan

artistic qualities which go beyond Art Nouveau. For instance, the analogous com-
position evident in the two outer panels and the mirror-image quality of the second
and fifth panels dissolve in spatial discontinuity. An overall view of the whole is
not possible; the viewer looks at the river landscape from different points and from
changing perspectives, under lighting conditions which also alter. This representa-
tion of the Aare valley is a far cry from the ornamental patterns of Art Nouveau.
Rather, it is a photographic portrayal—about a year before Klee's strong interest in
photography as a medium began. The impression of change corre-sponds with the
subject of the painting—the flow of the river and the movement of the water.
Klee's intense experiencing of nature on the banks of the Aare became a seminal
experience in his lifelong obsession with landscape as a theme. In particular, he was
interested in the dynamics, which for him was symbolized by the motion of water.
In 1938, nearly forty years after *Aarelandschaft*, and two years before his death,
Klee returned to the subject and, with *fliessend (Flowing)* (fig.), which he painted
in color paste on newspaper, arrived at an artistic solution, sparse and concise,
which became symbolic of his entire *oeuvre*. MBA

fliessend, 1938, 13 (13)
Flowing
Color paste on newspaper on cardboard
33.5 x 48.5 cm
Zentrum Paul Klee, Bern, private loan

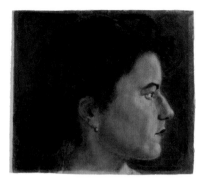

"I'm now painting experimentally in oils."

Paul Klee painted this small portrait of his sister Mathilde (fig.) in 1903 upon returning to his parents' house in Bern at Obstbergweg 6 after a seven-month trip to Italy. In this period, most of Klee's attention had been fixed on drawing and graphics, in particular nude studies and etchings (see p. 64). His painting was only experimental—he was looking for unconventional combinations of oil and water color painting, or tested the different effects of various primers. Klee made a self-critical note in his diary: "I'm now painting experimentally in oils. But I don't get beyond technical experiment[s]. For sure, I'm at the beginning or before the beginning!"

What Klee called an experiment "at the beginning" is in fact a harmonious, touching portrait of his sister. Compositionally keeping to a strict profile, the young artist realized the head in an almost classical painting style and recreated the physiognomy of his sister with careful modeling. The sensual, dark blue of the background lends calm and timelessness to the face.

Klee's interest in the human physiognomy was central to his work. In many of his drawings and paintings, he focused on the concise reproduction of characteristic facial features, often overdrawing them into caricature. But in his creative world, the concept of physiognomy took on a dimension which went far beyond the narrow definition of the word. Every single work has its own "picture physiognomy," and the idea became a metaphor for the shaping process which

Ohne Titel (Porträt der Schwester Mathilde), 1903
Untitled (The Artist's Sister)
Oil and watercolor on cardboard
27.5 x 31.5 cm
Zentrum Paul Klee, Bern

always began anew, giving each picture its unmistakable, individual "face."
Klee experimented in order to find his own access to painting. Gently feeling
his way into color, he remembered an associative image process from his child-
hood—as a nine-year-old, he had seen all kinds of figures and grotesque faces
in the surfaces of the marble-topped tables in his uncle's restaurant, and tried to
record them in pencil. As a painter, he used a similar process, in which he only
allowed the figure to emerge slowly from an amorphous pattern of brightly-
colored splotches of paint applied with a coarse brush. That was how he created
the physiognomy of the almost symmetrical composition *Sitzendes Mädchen
(Seated Girl)* (fig.), which was only given form later by the drawing of lines. With
considerable pride, Klee noted retrospectively in his diary that, in this way, he
had arrived at his very own "divisionist" process long before he had seen the paint-
ings of Georges Seurat (see pp. 82–83).
In his later work, Klee developed his "picture physiognomies" out of a completely
abstract vocabulary of form. During the creating process, the pieces may coa-
lesce—seemingly by accident—into shapes or symbols, as for instance in *Vorhaben
(Intention),* 1938, 126, where the physiognomies are made up of simple elements
(fig. p. 100). MBA

Sitzendes Mädchen, 1909, 71
Seated Girl
Pen and oil on canvas, bordered with
watercolor and pen, on cardboard
33.4 x 21.7 cm
Zentrum Paul Klee, Bern

"One could also say of the comedian that the mask represents art and the human being is hidden behind it"

Paul Klee's *Komiker (Inv. 4) (Comedian)* is part of a group of works known as the "inventions," eleven etchings from the years 1903 to 1905, whose meticulous technique and detailed, relief-like composition is reminiscent of drawings by the Old Masters. In his diary, Klee described the "inventions" as "opus I"—and called them the first fully valid examples of his individual artistic production. Inspired by artists such as Francisco de Goya and Honoré Daumier, Klee used his "inventions" to explore man's domination by his physical urges and how it becomes twisted by bourgeois sexual morals in works like *Jungfrau (träumend) (Virgin [Dreaming])*, 1903, 2, *Weib Unkraut säend (Woman Sowing Weeds)*, 1903, 4, or *Weib u. Tier (Woman and Beast)*, 1904, 13. Other drawings, like *Zwei Männer, einander in höherer Stellung vermutend, begegnen sich (Two Men Meet, Each Believing the Other to Be of Higher Rank)*, 1903, 5, and *Ein Mann versinkt vor der Krone (A Man Sinks Down before the Crown)*, 1904, 11, are of a political and socio-critical nature.

But no other subject is so intensely dealt with in the "inventions" as the comedian, which comes up in three different versions. All of them show the head of a man in profile, hidden behinds a mask. While the faces of the two first versions are recognizable as self-portraits, the third image focuses on a more fundamental reflection by Klee on his existence as an artist. Here, the discrepancy in the earlier

Komiker (Inv. 4.), 1904, 14
Comedian
Etching on zinc
15.3 x 16.8 cm
Zentrum Paul Klee, Bern

pictures between what the artist is and what he does gives way to a duality of artistic form and artistic personality. The Silenus mask, possibly a reference to Socrates, more or less peels off from the physiognomy of the artist. Klee compared this creative approach with a musical harmony: "One could also say of the comedian that the mask represents art and the human being is hidden behind it. The lines of the mask are paths to the analysis of the work of art. The duality of the worlds of art and of the human being is organic, like an invention by Johann Sebastian [Bach]."

Fifteen years later, a more mature and more successful Klee once more took up the theme of artistic self-perception and self-reflection in numerous self-portraits. The best-known among them is the drawing *Versunkenheit (Absorption)*, 1919, 75, which he also did as a lithograph with a large print run. The one in the Zentrum Paul Klee collection was colored by hand by the artist (fig.). Klee's subject here is less a reflection on the role of the artist than the self-portrayal of a person looking inwards, meditating. The artist no longer looks outwards; he looks inside himself—symbolized by the tightly-closed eyes and lack of ears. Klee had the lithograph of *Absorption* published in *Münchner Blätter für Dichtung und Graphik* in 1919, thereby portraying himself as a mystic, withdrawn from the world. This image was promoted by the artist himself and recorded by Leopold Zahn, the first man to write a book on Klee. For the opening paragraph to Zahn's monograph *Paul Klee: Leben, Werk, Geist*, Klee contributed the following, now-famous autobiographic comment: "in this world I am not comprehensible . . ." MBA

nach der Zeichnung 19/75 (Versunkenheit), 1919, 113
Copy of the drawing 19/75 (Absorption)
Colored lithograph
23.6 x 16 cm
Zentrum Paul Klee, Bern, Livia Klee Donation

Psychological Improvisations: Candide

Klee's early drawings were created in psychologically uncharted territory. Unlike in "inventions," (see p. 64), in which he was able to use symbolic orientation and to perfect himself, in his drawings of the following years, Klee sought ways of realizing psychological energies immediately. He noted in his diary that drawing had become his "primeval territory for psychological improvisation," an existential, often fearful process which opened up the path to his own unmistakable, personal imagery. "Sometimes I fling down a few nervous strokes which are full of expression. But I am gripped by a mild fear: another extension of the territory?"

The drawings created in the course of this process from 1903 to 1908 may be seen as psychograms of the young artist, as improvisations and experiments in which reassurance on his own personality and reflections are bound up with the reflection of his artistic means. As spontaneous sketches, they make no claim to be completed works; rather, they are artistic provocations in which Klee consciously gets around the aesthetic using fragmentation, mutilation, and dirtying. He frequently tore up the edges of his paper and mounted small fragments, sometimes no more than snippets, in an irregular arrangement on the cardboard (fig.). In his diaries, he defined the element of the ugly in his drawings in line with his philosophy as the ideal of a negative beauty. Most of the works in this group portray figures, but only "very indirectly" linked with any natural impression. Klee wrote: "Here I can

Schwangeres Mädchen sitzend: weiblicher Akt
mit Andeutung des Beinkleids, 1905, 16
Pregnant Girl Seated: Female Nude with Suggestion of Leg
Pencil and watercolor on two pieces of paper
12/15.3 x 15.5/17.1 cm
Zentrum Paul Klee, Bern

dare to give form to what weighs on my soul. Noting experiences which could delineate themselves in the black of night."

His skill in psychological improvisation on paper was what allowed Klee, in 1911 and 1912, to attempt to illustrate a literary work which he considered to be one of the most important in world literature: Voltaire's *Candide*. The writer's skeptical world view, expressed with a mixture of unbelievable horror and background humor, was a revelation for Klee the first time he read it. And when he reread it in 1911 in preparation for work on the illustrations, he found that "father Voltaire's" description of the dangerous vicissitudes in the life of the pure fool Candide had lost none of its power. For Klee, the challenge of illustrating *Candide* was to avoid simply reproducing events in the story in pictures, but to portray key scenes sympathetically, with all their enigmatic meaning. His figures are fine-limbed, shadowy creatures which draw their expression from the tension between lines and space. The prime example of the psychological energy of the sixteen drawings in the cycle is Klee's portrayal of a scene in chapter nine, in which Candide stabs blindly at his opponent, literally piercing him right through: "Il le perce d'outre en outre" (fig.). MBA

Candide, 9 Cap, Il le perce d'outre en outre, 1911, 62
Candide, Chapter 9, Il le perce d'outre en outre
Pen on paper on cardboard
15 x 25.2 cm
Zentrum Paul Klee, Bern

"And so I glide gently over into the new world of tonalities"

In the summer of 1905, Klee started using a new medium: blackened sheets of glass, which he worked on with a needle. Using the resistance of this unusual medium, he discovered a new form of artistic expression—the drawing scratched with a needle. In his diary, he described his discovery thus: "The medium is no longer the black line, it is the white. The light energy on a midnight background fits very well with the expression 'let there be light.' And so I glide gently over into the new world of tonalities."

Klee had tested cliché verre photographic copying methods years before his first experiments on glass. What interested him most about that was the reversal of the creation of form—from the positive to the negative. Similarly, the scratchings on glass had an artistically experimental nature which intrigued Klee; and—unlike Wassily Kandinsky—he was not interested in exploring the long tradition of this way of making pictures.

The energy of the white line stands out most clearly in the image *m Vater (My Father)* (fig.): Klee painted the glass with black ink and scratched the outlines of his father's portrait into it with precise strokes. He put a white coating onto the back of it, from which the powerful appearance of his father projects itself. Although examples such as this are based on a reversal of etching technique, in most of these etchings on glass, Klee took the process further into the realm of painting by putting colored backgrounds onto the scratched glass surface, and

m Vater, 1906, 23
My Father
Brush and drawing scratched with a needle,
backed with white, on glass
31.8 x 29.3 cm
Zentrum Paul Klee, Bern, Livia Klee Donation

Bildn. einer gefühlvollen Dame, 1906, 16
Portrait of an Emotional Lady
Watercolor and drawing scratched with a needle,
backed with white and other colors, on glass
24 x 15.8 cm
Zentrum Paul Klee, Bern

painted the glass directly with watercolor or ink. That caused the color to run across the smooth material, creating a soft, iridescent effect—particularly suited to landscapes.

Some of the scenes on glass are satirical, given fine details by the artist—such as the little dog with a nose ring in *Bildn. einer gefühlvollen Dame (Portrait of an Emotional Lady)* (fig. p. 68). An androgynous eroticism permeates the *Puppe an violetten Bändern (Puppet on Violet Ribbons)*, 1906, 14, which swings through the air like a monkey. There are even more earthy caricatures, such as *Verkommenes Paar (Wretched Couple)*, 1905, 31, and *Bildnis einer verblühenden Rotharigen (Portrait of a Fading Redhead)*, 1905, 18.

A total of sixty-four scratch drawings on glass are known today. They present a major challenge to the restorer—not only because the glass has cracked in some cases, but also because the paint often peels away from the smooth glass surface. Conserving and restoring these remarkable Klee works makes special demands on the restoration department of the Zentrum Paul Klee.

Klee's artistic works on paper benefited from the fine differentiations in the area of tonality which painting on glass taught him. In what are known as the black watercolors, Klee returned to the landscape motifs in his on-glass paintings, achieving finer nuances—working this time from the light into the dark—in the opposite direction (fig.). MBA

aus Bern, 1909, 50
View of Bern
Pen and brush on paper on cardboard
21.7 x 25.5 cm
Zentrum Paul Klee, Bern

"Color has got hold of me. I no longer need to grasp at it."

In April 1914, the three friends and artists Paul Klee, August Macke, and Louis Moilliet went to Tunisia at the invitation of the expatriate Bern doctor Ernst Jäggi. The journey was to become a key event in twentieth-century art history and took on legendary status for the Modern Movement.

A legend illuminated by the aura of the foreign and the exotic, by the glow of light and color—a legend which Paul Klee himself helped establish with a now-famous note in his diary: "I have stopped working. A deep calm runs through me, I sense it and feel very sure, with no hard work. Color has got hold of me. I no longer need to grasp at it. It has got hold of me forever, that I know. That is the revelation of this happy hour: color and I are one. I am a painter."

The wealth of color and the intensity of the natural light in the North African landscape inspired Klee to paint a series of delicate watercolors of impressive clarity and luminousness. Klee, who as a graphic artist had for years been highly critical of his own work as a painter, regarded the Tunis watercolors as his true breakthrough into color. Today, we put this distinction into perspective, as we know that the artist—under the influence of the color concepts in Robert Delaunay's Orphic Cubism—had created watercolors which technically and even formally, and as far as their range of colors goes, were hardly any different from the North African paintings.

During the two-week trip to Tunisia, in which Klee, Macke, and Moilliet visited

Tunesische Scizze, 1914, 212
Tunisian Sketch
Watercolor and pencil on paper on cardboard
17.9 x 12.2 cm
Zentrum Paul Klee, Bern, Livia Klee Donation

vor den Toren v. Kairuan, 1914, 216
Before the Gates of Kairouan
Watercolor on paper on cardboard
20.7 x 31.5 cm
Zentrum Paul Klee, Bern

Tunis, Sidi Bou Said, Hammamet, and Kairouan, Klee painted some twenty water-
colors and entered them in his handwritten *oeuvre* catalogue. After his return,
the artist continued to work on the theme—increasing the number of works with
Tunisia as their reference point. For instance, Klee worked on *Teppich der
Erinnerung (Carpet of Memory)*, 1914, 193, until 1921.

The Tunisia watercolors are typically loosely divided into geometric but not
schematic transparent colored areas. The scale runs across the primary and second-
ary colors, whose luminosity is brought out by Klee's nuanced use of complemen-
tary contrasts: red-green, blue-orange, yellow-purple.

The watercolors from 1914/15 at the Zentrum Paul Klee demonstrate the increas-
ing degree of construction and abstraction during the course of the Tunisia jour-
ney. At the very start, Klee made the self-critical note: "Got to work straight away
and painted watercolors in the Arab quarter. Attempted the synthesis of town
architecture and painting architecture. Not yet perfect, but very appealing, a bit
too much of the traveler's mood and enthusiasm, too much of me. It will become
more objective when the excitement begins to evaporate" (fig. p. 70). By contrast,
works like *vor den Toren v. Kairuan (Before the Gates of Kairouan)* (fig. p. 70)
and *Landhäuser am Strand (Country Houses on the Beach)* (fig.), are character-
ized by their architecture as paintings. But they are not completely abstract; they
bear traces of work in front of the motif—the sides of the papers have blank
spaces running along their edge, showing where Klee fixed the sheet to his paint-
box. MBA

Landhäuser am Strand, 1914, 214
Country Houses on the Beach
Watercolor on paper on cardboard
21.9 x 28.6 cm
Zentrum Paul Klee, Bern

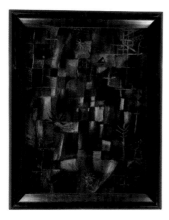

Composition with Windows

Paul Klee made the successful transition to working in oils in 1919. One of the most significant works from this period is *Komposition mit Fenstern (Composition with Windows)* (fig.). Its importance to the artist is underlined by the fact that he made a note on the back, indicating it should become part of his estate collection. To understand the structure of *Composition with Windows*, we must take a look at Klee's ideas on the anatomy of a picture. In 1908, he wrote in his diary: "Just like a human being, a painting has a skeleton, muscles, and skin. [...] One builds a framework for the painting under construction." This is true of the structure of *Composition with Windows*. At the first level, the construction is based on a network of lines, uprights, and right-angled refractions, which Klee drew on the cardboard in pen. The basic structure can only be discerned in a few places, as the artist later superimposed layers of red, blue, moss green, white, and black areas of color on it, representing its "muscles" and "skin."

Klee employed *Composition with Windows* in the winter semester of 1921/22 to illustrate the basic function of line as a design element to his pupils at the Bauhaus in Weimar. He said there were three ways to use line: he regarded the "active line" as one which developed freely. The "medial line" was one which described a closed shape such as a triangle, rectangle, or circle; while a "passive" line defined the boundaries of an area of color. All three types of lines are clearly unified in *Composition with Windows*.

Komposition mit Fenstern, 1919, 156
Composition with Windows
Oil and pen on cardboard; original frame
50.4 x 38.3 cm
Zentrum Paul Klee, Bern

Not until his final phase of work on the painting did Klee add a narrative, figurative dimension to its abstract levels. Using white paint, he added windows with gathered curtains or open shutters. Plant motifs, a black triangle with a dot, black and white stars, and the letter B complete the vocabulary of the painting. A look through this window-picture opens up the many-layered spatial dimensions of composition, which is itself the view of the inside and the outside at the same time. The watercolor *SommerLandschaft (Summer Landscape)* (fig.), which Klee painted in 1890 as an eleven-year-old, also reveals the view from a window. On a lined page from a school notebook, he painted a landscape with a church. On the hill to the left of the monumental steeple there is an isolated house, a schematic outline of a village, and four trees are dotted about the picture. The hill drops away from left to right, and is given limits by a wooden fence running parallel to the crest of the hill. At the top, the painting is signed "P. Klee Bern" and the words "der 20. März—SommerLandschaft" were added.

Several of the elements in this landscape foreshadow Klee's later work: the complex structure of *Composition with Windows*—the structuring of the space using connecting lines and areas, as well as the compilation of an artistic vocabulary of imagery—appear in the childhood drawing in embryonic form. AS

SommerLandschaft, 1890
Summer Landscape
Pencil and watercolor on paper from a notebook
17.3 x 21.7 cm
Zentrum Paul Klee, Bern, private loan

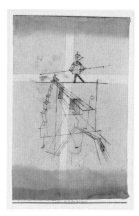

The Tightrope Walker

The theme of balance and imbalance is one of the central elements of Paul Klee's art theory focusing on movement. His basic premise was that objects may appear to be static and fixed, but are in fact in constant motion.

Accordingly, Klee interpreted balance in humans—which is bound to the physical law of gravity—as a dynamic process. "The feeling of verticality is alive in us, so that we do not fall ... In special cases we extend the horizontal, like the tightrope walker with a balancing stick," Klee wrote in his lecture notes on the teaching of artistic form at the Bauhaus in Weimar. In his lecture "The consciousness of weight as an artistic element," he expanded upon his theory in the area of the psyche and the perception of forces.

A figure from the world of theater and vaudeville stands as a metaphor for Klee's interest in the process of balance: *Der Seiltänzer (The Tightrope Walker)* (fig.). The unsteady skeleton of the work forms a white cross—a precarious axis over an unstable system of thin lines (recognizable examples are a rope ladder and a trapeze), which represent the instability of the action. Instability may be seen here as a physical and an existential motif. The tightrope walker stands at the edge of the abyss—and in Klee's understanding, the artiste becomes a metaphor for the artist.

The Tightrope Walker is also a remarkable work technically. In 1919, Klee developed his own copy technique, which allowed him to trace pencil and pen drawings

Der Seiltänzer, 1923, 121
The Tightrope Walker
Oil transfer drawing, pencil, and watercolor on paper,
marginal stripe with pen at the top, on cardboard
48.7 x 32.2 cm
Zentrum Paul Klee, Bern

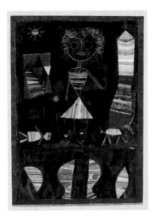

and to turn them into colored or watercolored oil transfer drawings (see fig. p. 90). From 1921 on, he frequently used this tracing method which gave him a combination of graphic and tonal expression.

A counterpoint to the artistic equilibrianism of the tightrope walker is presented by the watercolor *Puppen theater (Puppet Theater)* from the same year (fig.). It turns the theater into the imagined stage of childhood. The picture holds hidden depths which one does not suspect at first glance: the colorful, striped figures stand out as bright negatives on the dark background, but remain a part of it. The puppet on the ground appears to have been left there, forgotten; the small unicorn at right walks on regardless. The ambivalence of this statement is in line with the technical production of the work: it is made up of two separate parts; Klee retouched the join with black watercolor; the lower piece is a fragment of *Stilleben {{mit d. Würfel.}} (Still Life {{with the dice}})*, which Klee entered under the next consecutive number 1923, 22, in his *oeuvre* catalogue. Thus, the puppet theater becomes a false-bottomed stage with a vegetative underworld. MBA

Puppen theater, 1923, 21
Puppet Theater
Watercolor on chalk priming on two pieces of paper,
framed in watercolor and pen, on cardboard
52 x 37.6 cm
Zentrum Paul Klee, Bern

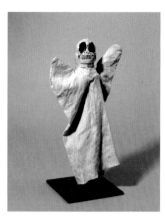 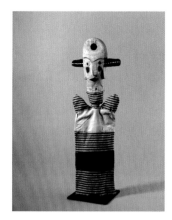

Lord Death and the Wide-Eared Clown

Between 1916 and 1925, Paul Klee made hand puppets of various materials for his son Felix. They became the actors in the plays Felix made up and performed for his parents and friends. Paul Klee, who had also constructed a theater for the puppets (fig. p. 77), followed the stories which his son remembered as "drastic" with evident pleasure. He "often watched, puffing on his pipe, with our big, wild, striped tomcat Fripouille, and laughed and laughed at the earthy entertainment proffered."

Klee made the first puppets for his son's ninth birthday. They were made of plaster and were called "Lord Death" (fig.), "Kasperl," "Gretl, his wife," "Sepperl, his best friend," "the Devil," and "the Policeman." With one exception, they were all destroyed in bombing in Würzburg in 1945. More than fifty years later, Felix Klee had clear memories of how these early figures came to be: "Clinging to my father's coattails, I—Felix—accompanied him on all his errands. Often they were just shopping trips or other excursions to places like the nearby Englischer Garten, or twice a year to the Auer Dult fair. [...] While he was shopping there, he would deliver me to the Punch-and-Judy theater. The performance, full of coarse Bavarian humor, awakened in me the dearest wish to own and run something similar. In 1916, this childish desire moved my father to make hand puppets and a matching theater for me himself."

When he first started making the heads and their costumes, Klee limited himself

Ohne Titel (Herr Tod), 1916
Untitled (Lord Death)
Hand puppet; head: painted plaster; costume: linen
Height 35 cm
Zentrum Paul Klee, Bern, Livia Klee Donation

Ohne Titel (Breitohrclown), 1925
Untitled (Wide-Eared Clown)
Hand puppet; head: painted plaster; costume: linen
Height 48 cm
Zentrum Paul Klee, Bern, Livia Klee Donation

to plaster and simple pieces of cloth from his wife's sewing box. But in time he widened the spectrum to include all kinds of materials: for the heads, he used beef bones and walnut shells, rabbit fur, and real hair bristles, matchboxes, and even an electric socket. The costumes—which were sewn by Sasha von Sinner, a Bern native living near the Klees and creator of the famous Sasha dolls—were made of cotton cloth in different patterns, linen, silk, velvet, corduroy, and leather. Although Klee does not appear to have explicitly planned them as works of art, some of the figures are almost like assemblages, which at that time were the latest invention of the avant-garde movement surrounding Pablo Picasso and Georges Braque. As the material basis grew, so did the range of characters: Kasperl, Sepperl, and Gretl were soon receiving visits from a bandit, a Russian peasant, and a Mr. Duck, as well as from strange figures such as the matchbox ghost and the electric socket ghost, the wide-eared clown (fig. p. 76), and the glove-ringed devil.

Some fifty hand puppets were created in all between 1916 and 1925. Thirty of them have survived. Along with those mentioned by Felix Klee, the lost puppets include a crocodile and the devil's grandmother. The first stage set was made of illustrations taken by Klee from the *Der Blaue Reiter* almanac. The theater, made from old picture-frames and remnants of fabric, was left behind in Weimar along with its sets and decorations (fig.). MBA

The Puppet Theater
Weimar, 1922

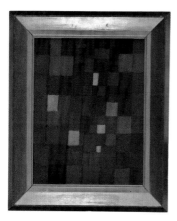

Pictorial Architectures

The oil painting *Bildarchitectur rot gelb blau (Pictorial Architecture Red, Yellow, Blue)* (fig.) is one of the square pictures, which Paul Klee worked on during his time at the Bauhaus in Weimar (1921–1925), and which he systematized in his Dessau Bauhaus period (1927–1930). Already years earlier, Klee had composed his first watercolors out of colored geometric shapes (see p. 71), and he had later transferred the principle into poetic variations (see fig. p. 72). The square pictures of the Bauhaus period are among the few completely non-representational compositions in Klee's *oeuvre*, and they bear witness to his systematic work on the theory of color.

Klee and other Bauhaus artists became more interested in the analysis of color as a means of creating artistic structure due to the influence of de Stijl artist Theo van Doesburg. The Dutchman held courses in Weimar in 1922/23 and criticized the lack of rationality in the Bauhaus lessons of the time. In his lessons in the years 1922 to 1924, Klee developed his own systematic theory of color, based on the concept of Philipp Otto Runge's color sphere and Goethe's theory of color. Unlike van Doesburg's de Stijl philosophy and contemporary scientific theories, for Klee, subjective experience drawn from artistic practice and the psychology of perception played an important role. The strict reduction of means to a square grid and the primary colors red, yellow, blue called for by Piet Mondrian and van Doesburg was out of the question for Klee. Rather, he expanded on the strict prin-

Bildarchitectur rot gelb blau, 1923, 80
Pictorial Architecture Red, Yellow, Blue
Oil on black priming on cardboard;
original, painted frame
44.3 x 34 cm
Zentrum Paul Klee, Bern

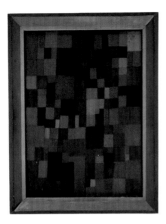

ciple with his own experiments on the relationship between complementary colors, on the effects of color contrasts and tonal modulations.

The title *Pictorial Architecture Red, Yellow, Blue* almost sounds like an ironical antithesis to the de Stijl dogma. *Pictorial Architecture* is based on a framework of rectangles whose orthogonality is virtually twisted by the intuitive balancing of color tones and thrown into disorder. For instance, the pure red is "heavier" than the blue; and can only be balanced with the addition of a small field of yellow, thereby setting off a shading-down via red-brown, orange, yellow-brown, and ochre, all the way to dark gray-black. Because of the different perception of primary contrasts on the one hand and tonal shading on the other, the eye of the beholder perceives various kinds of color harmonies and internal relationships which make the painting appear turbulent, both in color and dimension. Klee framed the composition with a fine gray frame—because gray, as an "absolute zero," at the same time forms a departure point for color.

This differentiation and wide spectrum of color is taken a step further in the more than twice as large oil painting *Harmonie aus Vierecken mit rot gelb blau weiss und schwarz (Harmony of Rectangles with Red, Yellow, Blue, White, and Black)* (fig.). The overall harmonious impression is created here using variations on blue-gray and salmon pink, and using color transitions from warm to cold and from light to dark. MBA

Harmonie aus Vierecken mit rot gelb blau weiss und schwarz,
1923, 238
Harmony of Rectangles with Red, Yellow, Blue, White, and Black
Oil on black priming on cardboard; original, painted frame
69.7 x 50.6 cm
Zentrum Paul Klee, Bern

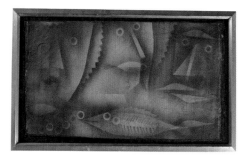

Movement in an Intermediate Realm

"In this element we suddenly become so light that [...] it is an art to go deeper, not to speak of touching the bottom. When swimming, fish [...] describe lines of freedom which have little more to do with the static world. For they are not bound to a plumb line. But on dry land, these animals are particularly helpless."
Paul Klee, from his *Pedagogical Estate*

During his time as a teacher at the Bauhaus, Paul Klee made an intense study of motion in the static, gravity-bound world and in that of the dynamic. The possibilities of movement open to birds and fish interested him particularly, as did their elements—air and water. Klee called water an intermediate realm, in which the law of gravity does not apply and freedom of movement becomes possible. Klee's collected works include more than sixty on the subject of fish, and about the same number of titles which contain the concept of water.

In *Fisch=Leute (Fish People)* (fig.), Klee portrayed the zero gravity of this intermediate realm through the delicacy and transparency of his application of color. He employed a clever spray technique and used fine mesh and perforated metal as templates. The artist, who was constantly experimenting with new methods, adapted the spray method from Hans Reichel or his fellow members of the Bauhaus, László Moholy-Nagy and Wassily Kandinsky, regarding it as a welcome addition, but also as a technical challenge.

Fisch=Leute, 1927, 11 (K 1)
Fish People
Oil and tempera, partly sprayed, on plaster priming
on canvas on cardboard
28.5 x 50.5/51 cm
Zentrum Paul Klee, Bern

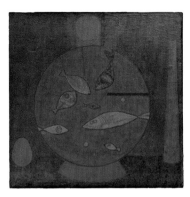

Apart from raising fundamental artistic and technical questions, *Fish People* contains a wealth of the delicate, ironic illusions typical of Klee's artistic humor. At first appearance: a man with a moustache—seen on the right—and two women are gazing at a fish. A closer look, however, brings out a different picture: a further face appears in profile at the left-hand edge of the painting; what can be interpreted as a mouth in the middle, is also a fish; the man's moustache becomes a tailfin; the bony fish is in profile, but both eyes are visible. The double meaning corresponds with the irony of the image: the figures standing outside an aquarium watching fish—but in the painting, they appear submerged in the same element. They literally become fish people. Not for nothing did Klee put an equals sign in his German title.

The ease of movement in water is the subject of *Fische im Kreis (Fishes in a Circle)* (fig.), which, like *Fish People,* was done during Klee's time at the Bauhaus in Dessau. Removed from their natural surroundings and incorporated into the circle, these fish creatures appear to drift in their space. The circle can be interpreted representationally as a fish bowl, but above all, it draws a boundary between the intermediate realm and the dark outside world where gravity rules. MBA

Fische im Kreis, 1926, 140 (E 0)
Fishes in a Circle
Oil and tempera on black glue priming
on muslin on cardboard
42 x 43 cm
Zentrum Paul Klee, Bern, Livia Klee Donation

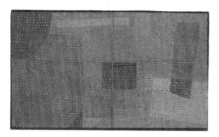

"Pointillist" Paintings

At the start of the thirties, Paul Klee discovered a new form of expression in the use of color: in a process he called *pointillieren,* he dispersed the colors across the surface as dots. In doing so, Klee took up the divisionist technique of the French Neoimpressionists, which Georges Seurat had taken to methodic perfection by breaking the world of color down into thousands of dots.

While Seurat aimed to reproduce optical phenomena as accurately as possible, Paul Klee developed his pointillist technique completely independently of visible nature. Klee's technique began where Seurat's Divisionism left off: the dot of color ceases to be a tool of those seeking to portray nature or light; rather, it becomes an autonomous, structuring element in a transparent framework. In the words of Jürgen Glaesemer, it becomes the "germ cell of all artistic energies, a color impulse." Within Klee's work, the new formal method represented a consistent extrapolation of his experiments in the twenties, in which he juxtaposed pure colors—putting them in relationship to one another as a means of giving form to surfaces and space. Several pointillist paintings, with their scaffold of rectangular fields of color, are reminiscent of the "Quadratbilder" of Klee's Bauhaus period (see pp. 78–79).

The same is true of *durch ein Fenster (Through a Window)* (fig.), whose surface is divided by a cross into four rectangular segments. If one interprets the painting as the view through a window, then behind it are countless, overlapping fields of

durch ein Fenster, 1932, 184 (T 4)
Through a Window
Oil on gauze on cardboard
30 x 51.5 cm
Zentrum Paul Klee, Bern, Livia Klee Donation

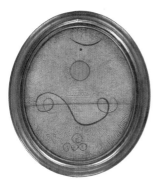

color, which in turn are overlaid with rectangular, dotted fields of color. Klee distributed these fields—originally white—over the entire surface with a paintbrush and, in a subsequent process, coated them with a thin layer of colored varnish. Light effects arise from the interplay of transparent spots and, interacting with the colored background, create a fluctuating three-dimensional impression. The alternation of several differently structured surfaces, with which one could draw the musical analogy of different voices, was described by Klee himself as an image of polyphony. In the many visual layers of *Through a Window,* seeing itself becomes visible as a process of simultaneous polyphone means of perception.

In *Ranke (Tendril)* (fig.), light gains the dimension as a source of life in addition to its role as the constituent element of perception. The vegetable growth of the tendril orientates itself along the earth's horizon. Anchored in the soil below, it strives upward toward the light of the cosmos, symbolized by the sun, moon, and stars. In Klee's essays on form from the early Bauhaus period, we find an almost identical, ring-like shape as a symbol of the free, unbound unfolding of line.

In *Tendril,* the link between the cosmos and the Earth is reflected in the materiality of the picture. The spherical lightness of the dots contrasts with the composition of the ground, which Klee sprinkled with sand and gave a whitish coat. To the artist, the painting held a totality: an oval, framed in profiled brass, it becomes a miniature cosmos in itself. MBA

Ranke, 1932, 29 (K 9)
Tendril
Oil and sand on wood; original brass frame
38 x 32 cm
Zentrum Paul Klee, Bern, Livia Klee Donation

"Never quite reaching where motion becomes endless!"

In *gehobener Horizont (Elevated Horizon)* (fig.) Paul Klee's longstanding fascination with motion as the basic element of artistic form intensified into symbolism. Even twelve years earlier, he had derived the development of the visual from the concept of motion: "Overcoming the first dead calm was the first act of motion (line)," he wrote in his 1920 *Schöpferische Konfession* (Creative Confession), setting the course he was to follow for the coming eleven years as a teacher and an artist at the Bauhaus.

Starting with the "active line, which moves freely," Klee explored the fundamentals and forms of motion—whose energy he represented with an arrow. In this exploration, his central theme was the escape from restrictions of stasis by overcoming gravity—the transition from inhibited, earthly movement, to free, cosmic motion.

The arrow in *Elevated Horizon* has precisely that function: its dynamics also "elevate" the colored stripes of the horizon and follow the movement upward. But, like every earthly movement, this rise is also bound by gravity: "Never quite reaching where motion becomes endless! The realization that where there is a beginning, there can never be endlessness."

This dichotomy is revealed in the materiality of the painting. The idiosyncratic choice of paint and backing—casein paint on burlap—gives the impression of an almost rough, unworked surface, which undermines the color effects of the

gehobener Horizont, 1932, 328 (A 8)
Elevated Horizon
Casein on burlap on stretcher
79.5 x 59.5 cm
Zentrum Paul Klee, Bern, Livia Klee Donation

horizontal stripes. This discrepancy leads to a contradiction between the message and the material of the painting.

Klee also explored the subject of escaping gravity in paintings with a three-dimensional construction, which appear to drift in space. They are based on precise constructive principles, yet are frequently irrational in their spatial logic. In *Schwebendes (Hovering)* (fig.), the corners of the overlapping four-sided figures (squares, trapezoids, and rhomboids) are only partly "rational," that is, linked by two corresponding corners. Other links are "irrational," or randomly created. This gives an impression of a three-dimensional structure with a disturbing perspective. Its surfaces appear to belong to different spatial levels, and to change in the perception of the observer.

Klee worked out the basis for his illusionary, drifting, three-dimensional constructions in his Bauhaus teaching on "Planimetric Form," in which he systematically went through the possibilities of "rational" and "irrational" construction schemes. In his artistic work, he gave free reign to these principles, creating dynamic three-dimensional works "with no up and no down, a kind of Aristophanes's castle in the air (for planes and balloons too)." MBA

Schwebendes, 1930, 220 (S 10)
Hovering
Oil, partly stamped, on canvas on stretcher;
original frame
84 x 84 cm
Zentrum Paul Klee, Bern

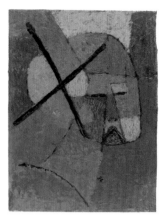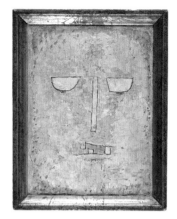

Struck from the List

Paul Klee is considered an apolitical artist. He made hardly any socially critical statements, did not portray the horrors of war, nor did he offer religious opinions. He concentrated absolutely on his art, and kept an ironic distance from his human and political surroundings. But how did Paul Klee—as a German citizen—respond to National Socialism? As a modern artist, he not only saw Hitler's rise to power, he was personally affected by it. After Hitler became chancellor of the Reich on January 30, 1933, Paul Klee faced increasing harassment, which culminated in his suspension and later dismissal from his post as professor at the Düsseldorf academy. The Nazis decried him as a "cultural Bolshevist" and a "Galician Jew," and his apartment in Dessau was searched in his absence. In the months that followed until he left for Switzerland, Klee lived with his family at his home in Düsseldorf, where—left to his own devices—he continued to work.

Despite the turbulence, in 1933 Klee created more works than ever before (482). More than 200 of them deal with subject matter such as education, militarism, violence, humiliation, flight, and helplessness. Several of Klee's 1933 paintings may be viewed as commenting upon the political turmoil in Germany.

Klee's artistic confrontation with the misanthropic and philistine policies of the Nazis underwent an intensification in the oil painting *von der Liste gestrichen (Struck from the List)* (fig.). The face can be seen as a self-portrait, reduced to

von der Liste gestrichen, 1933, 424 (G 4)
Struck from the List
Oil on paper on cardboard
31.5 x 24 cm
Zentrum Paul Klee, Bern,
Livia Klee Donation

Kopf eines Märtyrers, 1933, 280 (Y 20)
Head of a Martyr
Watercolor on plaster priming on gauze
on cardboard; original gold frame
26 x 20.5 cm
Zentrum Paul Klee, Bern, Livia Klee Donation

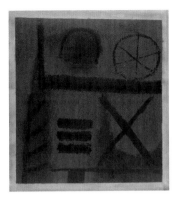

schematic fields of color, it appears numb, branded by the black cross, the stamp of censorship and annihilation. This message finds its material counterpart in the roughness of the thick paint, which seems to have been slapped on. To be "struck from the list" meant not only a strict ban on teaching and exhibiting for Klee and all modern artists declared "decadent" by the Nazis—from 1937, it also meant the systematic removal of their works from public view.

The cross has a many-layered, ambivalent significance in Klee's visual vocabulary. In *Struck from the List* it is a dividing element, a symbol of the ban; by contrast, in other works it stands for the unification of opposing forces at one point and becomes a marker of combination and synthesis, and therefore, *eine Formel des Künstlers (A Formula of the Artist)* (fig.), as a 1937 painting is titled.

While *Struck from the List* aims to make a political, rather bold point, another 1933 painting *Kopf eines Märtyrers (Head of a Martyr)* (fig. p. 86) takes up another theme: the psychological dimension of the suffering caused by the Nazis. The head of the martyr is completely bound up with the painting ground, a very fragile construct of plaster and gauze. The suggestions of eyes, nose, and mouth are little more than markers. The face is the vulnerable material itself. With this simile, the traces of working themselves become symbolic wounds. The title's association with Christian martyrdom has its counterpart in the materiality of the image. MBA

eine Formel des Künstlers, 1937, 249 (W 9)
A Formula of the Artist
Tempera on paper
31 x 28.5 cm
Zentrum Paul Klee, Bern,
private loan

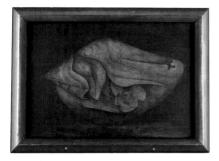

Sea Snail King

"The object expands beyond its appearance through our knowledge of its interior," wrote Paul Klee in his 1923 "Wege des Naturstudiums," (paths of nature study), his essay for the publication *Staatliches Bauhaus Weimar 1919–1923*. He contended that a dialogue with nature gave the artist a fresh perspective on the form of things, and made him able to draw intuitive conclusions about their inner life.

Ten years later, these ideas were put into practice in the watercolor *Meerschnecken-König (Sea Snail King)* (fig.). The first two words of the title describe the subject neutrally, as a sea animal. But the additional epithet, king, reveals this strange creation as a figment of the imagination, a mythical creature. A new world between nature and art, dream and reality, opens up before our eyes. The thing itself is ambivalent and impossible to grasp—the corrugated cone, running to a point on the left, is reminiscent of a sea snail, but the overall shape is more like that of a shell. In the middle, one dimly perceives a bird with a large eye; other parts recall to mind an amoeba or a fat-bellied fish.

Klee collected mussel and snail shells, storing them carefully in his collection of natural objects. On August 6, 1927, he wrote to his wife Lily from his vacation in the south of France: "I have had a bathe nearly every day, it is very entertaining, one sees shrimp, sea anemones, crimson marine plants, hermit crabs, sweet snails big and little, flora above and below the water, simply wonderful." Thanks to

Meerschnecken-König, 1933, 279 (Y 19)
Sea Snail King
Watercolor and oil on priming on muslin on plywood;
original, silver plated, and painted frame
28.4 x 42.6 cm
Zentrum Paul Klee, Bern

his care and enthusiasm as a collector, the shells which became the models for *Sea Snail King* have been preserved (fig.).

Klee painted *Sea Snail King* in watercolors and oils, partly as varnish, on muslin stretched over plywood. He created a many-layered texture using fine brush strokes, so that the surface shimmers in several tones. The majestic sea creature shines out in warm colors, fluorescent enough to cast light at the bottom of the sea. Its true nature is hidden in the twilight of the depths. The dialectic between interior and exterior is made concrete in the many layers and many meanings of the *Sea Snail King*.

The little picture has been preserved in its original frame. Photographs of Klee's studio at Kistlerweg 6 in Bern reveal that it hung on the wall there, accompanying the artist in his final creative period. It was painted in 1933, an extremely turbulent year for Klee. It was the year in which he suffered particularly vitriolic defamation by the Nazis, who, after suspending him from his professorship at the Düsseldorf academy on April 21, eventually drove him into exile in Switzerland. He had secretly made a large number of pencil drawings, clearly attacking the "National Socialist revolution" and ironically commenting on its institutionalized persecution and reactionary cultural policies. This historical point makes a further reading of the *Sea Snail King* possible—as a portrayal of Klee's own hidden artistic existence in the depths. There, the artist rests, a sea snail king protecting his inner life from any kind of manipulation. AS

Shells from Paul Klee's collection
Zentrum Paul Klee, Bern, Klee Family Donation

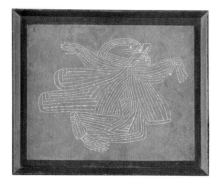

"Art is an image of creation"

Paul Klee entered the painting *Der Schöpfer (The Creator)* (fig.) in his *oeuvre* catalogue in 1934 under number 213. Next to that, he noted: "neglected for several years." Klee frequently left paintings sitting in his studio for long periods, only to pull them out at the right time, rework them, or paint them over. He probably began *The Creator* in his Dessau Bauhaus period; he did not work on it again until he had left Germany to live in Switzerland.

The forerunner of the painting was the sketch *Creator I*, done in 1930 (fig. p. 91). Klee copied its contours using the oil transfer process *(Creator II*, 1930, 35) and then transferred them to the canvas. Klee invented the oil transfer drawing himself in 1919, and it allowed him to copy drawings: he painted a sheet of paper with black oil paint, and he used the sheet as tracing paper, laying it between the drawing to be copied and a blank sheet. He traced the outlines of the drawing using pinpricks. In the case of *The Creator,* Klee spent a long time seeking a satisfactory way of working the traced lines into the painting; eventually he invented a process whereby he stamped the paint onto the primer using a spatula.

The choice of colors has a particular significance in this painting, as the pink primer becomes the actual background, into which the figure is placed as if on a film. The delicate pink of the primer gives the image a cheerful note, matching the finely-contoured figure of the creator. It is a master work of Klee ambiguity: The creator's awkward arm movement reminds one of a bird with clipped wings; the amorphous

Der Schöpfer, 1934, 213 (U 13)
The Creator
Oil, lines stamped onto canvas on stretcher;
original, painted frame
42 x 53.5 cm
Zentrum Paul Klee, Bern

feet are not godlike. But at the same time, the lightness of his contours make him truly seem to hover; he appears weightless and transcendental. Klee drew a likeable, chagrined creator—perhaps as a parody on the titanic earnest of Michelangelo's creator (who also has an outstretched arm) in the Sistine Chapel.

The subject of creation or genesis, which is used here with all its meanings, played a fundamental role in Klee's conception of art. Giving form to a work of art was for him an artistic process of creation comparable with creation in nature. Even in his earliest diary entries, he used the notions of "creation" and "genesis" as synonyms for the work of the artist and the making of art. In his 1920 essay *Schöpferische Konfession* (Creative Confession), he raised this analogy to his artistic credo. Four years earlier, he had described the comparison between God and himself as an artist: "I take a remote original creationary point, where I presuppose formulas for man animal plant, stones and for the elements, and for all circulating forces. [...] Art is an image of creation. God didn't bother too much with the stages as they came up, either." MBA

Schöpfer I, 1930, 34 (M 4)
Creator I
Indelible pencil on paper on cardboard
35.5 x 52 cm
Private collection, Switzerland

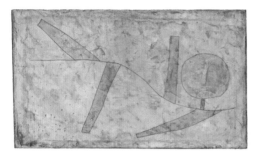

Dialogue with Nature

Landschaft am Anfang (Landscape in the Beginning) (fig.) was painted in 1935, during a period in which Paul Klee was seeking a new artistic orientation. After emigrating to Switzerland, he began to experiment with form—"with a small orchestra," as he wrote to his friend, the art historian Will Grohmann.

To Klee, nature is the image of creation. Growth and genesis are key concepts for formal development and for the movement which expresses itself within the painting. Klee sees nature as cyclical: the beginning and the end are dimensions which ultimately dissolve in the complex of a universal whole; the beginning—a question: "What was in the beginning?" With these words, Klee began one of the texts in his *Pedagogical Estate, Unendliche Naturgeschichte* (Unending Natural History), which searches for the origins of nature and the cosmos and regards the approximate ("only gray approximate") as the essence of things. Klee's *Landscape in the Beginning* starts in the anywhere; it cannot be placed in space or topography, it could be extended on all sides of the painting, its boundaries appear temporary. The open structure is modeled in restrained greens. Space and color crystallize out of layer upon layer of paint. A relief-like structure is created, the landscape "grows" successively in the process of creation; an unusual experiment by the artist to overcome the flatness of the panel painting and to imagine an abstract landscape of forms and colors as an artistic object.

This atmospheric picture, which does not portray a landscape, but freely and openly

Landschaft am Anfang, 1935, 82
Landscape in the Beginning
Watercolor on plaster priming on gauze
on cardboard
33.5 x 58.5 cm
Zentrum Paul Klee, Bern, private loan

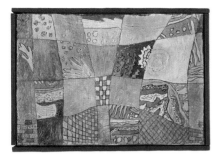

associates space and nature, is crisscrossed by black, "wandering" lines; their orientation is without goal or perspective. They run through the "landscape" like a rhythmic melody, whose improvised nature may be felt here and there; a fantasy without beginning or end, in which—picked out in restrained colors—plant elements may be seen.

The small 1932 painting *Garten=rhythmus (Garden Rhythm)* (fig.) is designed over a rhythmically structured, netlike grid. Each of these surfaces has its own, detailed life of ambiguous, ornamental forms held together by unsteady, imprecisely balanced boundary lines. A mosaic of individual miniatures, heterogeneous, bluntly-modeled, and in colors linking them to one another, form a carpet-like composition; a woven garden, rhythmic in itself—certainly in the musical sense—begins to oscillate. Here, too, Klee focused on a color spectrum associated with natural plant elements. Abstraction functions as an image of reality. Parks and gardens are popular themes in Klee's paintings; there are many variations on them in his drawings as well. On top of that, parks and gardens have a metaphoric meaning in composition. They characterize the correspondence and ambivalence of growth and stasis, order and chaos, chance and planning, nature and art. In Paul Klee's philosophy, every picture is a new beginning for a compositional concept, in which opposing principles combine into a unified image. TOS

Garten=rhythmus, 1932, 185 (T 5)
Garden Rhythm
Oil on primer on canvas on cardboard;
reconstructed frame strips
19.5 x 28.5 cm
Zentrum Paul Klee, Bern, private loan

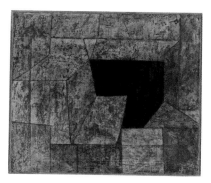

The Gate to the Depth

Paul Klee painted *das Tor zur Tiefe (The Gate to the Depth)* (fig.) as his final work of 1936, in which his output was severely restricted by illness. Only twenty-five works were added to his *oeuvre* catalogue—fewer than in any previous year. Without a doubt, the title of this picture expresses a deeper meaning: it conjures up approaching death. Formal tensions in the painting create a sharp contrast between the different elements and angles. According to the rules of color perspective, Klee gave the work a clear spatial order. This causes the black shape in the middle to be perceived as a lower-lying area. The light red shape, by contrast, appears to be a surface folding outward. The structure of the surface makes it come across as a hard substance, earth, or rock. An exception to this is the black shape, which, as an open, black abyss, stands in contrast with the light layers of color. Klee made the ochre, greenish, and gray surfaces look most stonelike. He may have been thinking of Rainer Maria Rilke's 1904 sonnet *Orpheus. Eurydike. Hermes.*: "It was a wondrous mine of souls. [...] Rocks were there and creatureless forests. Bridges over nothingness and that great gray blind pool, which hung far above its distant depths ..." *The Gate to the Depth* is a direct confrontation with Hades, the Greek god of the underworld. Klee is evidently exploring the infinite darkness of the underworld, which one may enter but never leave. The gate itself is not directly visualized—it remains a dark imagining in the deep black void—and thus, a deep contrast with the harmonious color scheme of the rest of the painting.

das Tor zur Tiefe, 1936, 25 (K 5)
The Gate to the Depth
Watercolor on priming on cotton
on cardboard on stretcher
24 x 29 cm
Zentrum Paul Klee, Bern, private loan

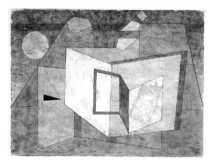

Unlike *The Gate to the Depth, geöffnet (Opened)* (fig. p. 95)—painted three years earlier in Düsseldorf—shows a light, interlocking landscape of basic geometric shapes such as the rectangle, triangle, and circle. On the left-hand side, a circular shape touches its skewed margin. The complicated spatial construction is distantly reminiscent of a mountainous landscape. It could also be read as an interior— were it not for the bright, red circle in the left half of the picture, unmistakably representing a heavenly body. The full moon is seen against the blue-green infinity of the heavens. As abstract as the hill and box shapes are, the impression of per- spective remains. A small black arrow underlines the effect. It points from the left toward an open door consisting of a blue frame and a dark brown surface. It opens the pathway into an unknown region whose bright colors give an impression of warmth. Klee's primary aim was not to show the movement represented by the arrow; rather, he created an abstract, fantastic landscape reflecting the mood. Klee was experimenting with the motifs "door" and "pathway" immediately before and after *Opened*. His previous color painting was entitled *Nachbar-Türen (Neighboring Doors)*, 1933, 293, and the subsequent one was called *Wege am Dorfrand (Paths on the Edge of the Village)*, 1933, 307. Each of the paintings deals with different kinds of possibilities for movement. AS

geöffnet, 1933, 306 (A 6)
Opened
Watercolor, pen, and pencil on muslin
on plywood
40.5 x 55 cm
Zentrum Paul Klee, Bern, private loan

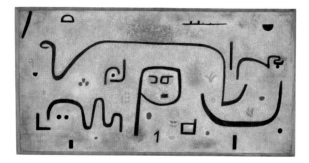

Sweet and Sour Fruits

Insula dulcamara (fig.) is the largest of Klee's finished paintings. Its original title was *Insel der Kalypso (The Isle of Calypso)*. Delicate colors, reminiscent of blooming plants, contrast with hard black lines; open, dynamic shapes with closed, static ones. As a base, Klee used printed newspaper mounted on burlap; he painted it with oil paints and colored paste.

The symbols are taken from an elementary vocabulary of form and can be read in different ways. A line running from left to right in the top half of the picture is reminiscent of a serpent, the shape to its right looks like a piece of Arabic calligraphy. In the middle, a sallow face may be seen, which Klee returned to in his painting *Tod und Feuer (Death and Fire)*, 1940, 332, in the last year of his life. The original title of the painting refers to the initial image from Greek mythology—of Odysseus's sojourn on the isle of the nymph Calypso. While working on it, Klee broadened the subject to make a more open statement. The title *Insula dulcamara* awakens exotic associations, but at the same time it points out the opposites of sweet (Lat.: *dulcis)* and bitter (Lat.: *amarus*). He probably first refers to medicinal plants: *Solanum dulcamara* is the Latin name for the highly poisonous solanaceous herb bittersweet, which was used for healing due to its anti-inflammatory and metabolism-boosting properties. It is used to treat rheumatism and helped ease Klee's scleroderma. The scarlet fruits and small brown leaves dispersed about the painting are direct references to ripe *Solanum dulcamara*.

The landscape-format painting *Früchte auf Blau (Fruits on Blue)* (fig. p. 97) takes

Insula dulcamara, 1938, 481 (C 1)
Oil and colored paste on newspaper on burlap;
original frame strips
88 x 176 cm
Zentrum Paul Klee, Bern

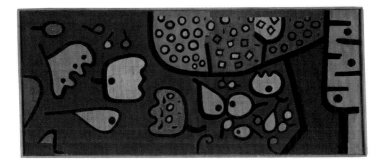

up a different aspect of the theme. Various kinds of fruit lie as if dropped on a dark blue background surrounded by black-bordered fields in which tree shapes can be discerned. Ochre and rust-brown tones conjure up associations of harvest time. The abstract elements can only be interpreted representationally via additions such as black flecks on the "fruit." These symbols are ambiguous, at times taking on the appearance of eyes.

The painting is clearly structured: the apparently random arrangement of the fruits on a blue background contrasts with the rows of pictorial elements in the four color fields at the top and the rhythmic division of the ochre tree shape at the right edge. The eye sees the switch between different large, closed shapes as a dynamic process.

Klee's interest in botany and the structures of vegetable growth runs through his entire *oeuvre*. He was particularly fascinated by fertility and the development of fruits. Key works in the context of Klee's trip to Egypt testify to this—such as *Monument im Fruchtland (Monument in the Fertile Country)*, 1929, 41, *Blick in das Fruchtland (View into the Fertile Country)*, 1932, 189, as do others from his final years, with titles like *üppige Frucht (Luxuriant Fruit)*, 1939, 339, *Coelin-Frucht (Coelin Fruit)*, 1938, 28, and *Hymnus der Fruchtbarkeit (Hymn to Fertility)*, 1939, 813. The obvious frequency of works with this kind of title in the period 1939 to 1940 is a metaphor for the almost unbelievable productivity of the artist at the end of his artistic career, which Paul Klee himself experienced as a process of creative maturity and harvest. AS

Früchte auf Blau, 1938, 130 (J 10)
Fruits on Blue
Colored paste on newspaper on burlap,
on stretcher; original frame
55.5 x 136 cm
Zentrum Paul Klee, Bern

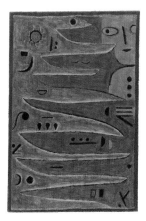

The Gray Man and the Coast

A line beginning at the top edge swings back and forth, dividing the painting into horizontal segments. The "gray man" appears to observe this course, which the title describes as a coast. We too look down on a landscape of fjords far below us, reading the blue surface as sea, the bow-shaped lines as boats, the horizontal bar with three dots in the middle of the painting as a ship.

But this perspective changes when we do not regard the painting from a distance, but perceive it as a mirror, facing the objects in the canvas squarely. This unexpected change in perspective may be understood as Klee's comment on the relativity of visual perception: the gray man is perceiving subject and reflected object at the same time—and is revealed as an indirect self-portrait of the artist.

A similarly sinuous line is found in *heroische Bogenstriche (Heroic Strokes of the Bow)*, 1938, 1, painted about two months earlier. Paul Klee's close friend, the art historian Will Grohmann, interpreted this work in 1966 as Klee's homage to the violinist Adolf Busch (1891–1952), who was also a friend. The black lines and symbols on the blue background appear as motifs of the sweeping bow.

One suspects that the repetition of this motif—so unusual for Klee—was an autobiographical note. The hypothesis is supported by the abstracted self-portrait of the artist as the gray man. Seen in this light, both works—*der Graue und die Küste (The Gray Man and the Coast)* especially—illustrate Paul Klee's painful farewell to music. Felix Klee, the son of the artist, wrote in 1960: "The doctor's

der Graue und die Küste, 1938, 125 (J 5)
The Gray Man and the Coast
Colored paste on burlap on a second layer of
burlap on stretcher
105 x 71 cm
Zentrum Paul Klee, Bern, Livia Klee Donation

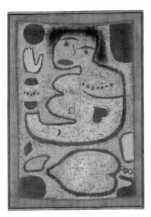

order to give up smoking and stop playing the violin was very hard for Paul Klee."
For the impassioned violinist, who in his youth had spent a long time deciding in
favor of the fine arts and against music—while still using it as an important source
of inspiration for his work—having to renounce music for medical reasons must
have been drastic.

Paul Klee returned to the motif of complaint in *Liebeslied bei Neumond (Love
Song at New Moon)* (fig.) one year later. A female figure looks out of an indefinable
background directly at the observer and sings her love song under a new, blue
moon. Her song is underlined with a dramatic gesture. In her reduction to the sur-
face, she is all the more expressive. But the moon is dark, her song remains unheard,
the blue heart points flatly down and is, at the same time, outside her body—on
the ground, robbed of its blue color. The bright yellow right hand, cut off from the
body, and the form at the right edge in the same yellow, underline the melancholy,
torn mood of the painting. The source of the complaint in this picture is not clear
either. The female figure may be placed in a further context, linked with the Earth
goddess Gaia, who bemoans the death of her sons, the giants. Supporting this
thesis is the fact that a work with the title *Brustbild Gaia (Portrait Bust of Gaia)*,
1939, 343 follows *Love Song at New Moon* in Klee's *oeuvre* catalogue. AS/NG

Liebeslied bei Neumond, 1939, 342 (Y 2)
Love Song at New Moon
Watercolor on burlap on a second layer of
burlap on stretcher; original frame strips
100 x 70 cm
Zentrum Paul Klee, Bern

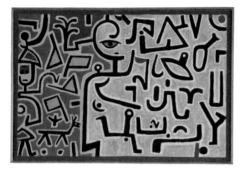

That makes me "abstract, with memories"

Paul Klee's later style is characterized by a specific language of imagery which was constantly altered and further developed in the years 1937 to 1940. It is an intensifying process of simplification, combining scriptural, calligraphic, number-like essences with fields of color. Klee transcends reality, creating paintings and drawings incorporating outward things into dreamlike, surreal spheres. Hieroglyphs appear as mysterious codes which seem almost impossible to crack—as if Klee, insisting on his own rules, refuses to acknowledge every attempt at decoding, every transposing of the secret language of form into fact, into knowledge, into categories of understanding. "Calligraphy is part of mediumistic writing down, drawing from the outside in," Klee said in his pedagogical writings. The consistency with which he expresses his line, his autonomous language, his image consciousness, is penetrating. The individual nuances in the order of his images are oriented toward an overall perspective and toward openness, with which Klee makes artistic forays into the complex dimensions of reality. Klee reveals art as an expression of creative freedom and as a symbol of that which keeps the world turning.

Vorhaben (Intention), painted in 1938 (fig.) on newspaper, shows a constellation of individual symbols in a state of latent drifting. Figures set something in motion— the spark which sets off an unsteady, directionless, seemingly randomly-directed condition with no beginning and no end. The painting's two subtly-graded, monochrome pages, on which the black symbols run riot, refer to each other in counter-

Vorhaben, 1938, 126 (J 6)
Intention
Colored paste on newspaper on burlap
on stretcher; original frame strips
75.5 x 112.3 cm
Zentrum Paul Klee, Bern

point. The correspondence in the turbulent, hieroglyph-like symbols in black, gray, brown, and pink—and a blue "eye of Horus"—stands for composure, for movement under control. The painting is an allegory of the "intention" of integrating art and life; a synthesis of man and artist. Klee sets forth his idea on the contemporary stage of a newspaper, whose hard media language—meant to inform—is present in the background, but is at the same time withdrawn and re-encoded. The backdrop of current affairs was critical to Klee at the time. Dictatorship and violence had driven him out of Germany; given to his own personal and health crisis, he reflects all the more intensely and deeply on the war that has begun.

Schwarze Zeichen (Black Signs), also from 1938 (fig.) plays on the dialectics of black and white. The dimensions of content in these two colors were to Klee the very essence of polarization. He seeks a balance between seemingly randomly-driven, drifting elements and signs. They represent motion as a basic principle of artistic creativity. The signs' individual, inherent life is expressed—as Klee once said of the perceptional function of the eye—"free from the constraints of time and space." A single impulse sets a rhythmic arrangement of signs in motion. The painting comes to life with inspirational energy, oriented freely and unconstrained across the entire painting. TOS

Schwarze Zeichen, 1938, 114 (H 14)
Black Signs
Oil on cotton on cardboard nailed onto
a wooden frame
15 x 24 cm
Zentrum Paul Klee, Bern, private loan

Destroyed Labyrinth

In 1937, the outbreak of an incurable disease forced Paul Klee to stop painting for some months. After that, he began to develop a new, pregnant style, generally categorized as his later style.

It is characterized by a reduction and simplification in all areas of artistic form. Klee used hieroglyph-like signs, inventing his own symbolic language—which can only be partially interpreted or understood only in the context of the entire work. Klee took on a wide spectrum of themes— reaching from childhood, to demons, religion, myths, nature, and the world of emotions, to disease and death. An ever-recurring theme is the quest for the origin of creation and the alternation of construction and destruction.

Letter-like ciphers are created from signs—at first in an unordered form, as if in their original state. Paintings with titles like *Zeichen verdichten sich (Signs Clustering)*, 1932, 121, and *Anfang eines Gedichtes (Beginning of a Poem)*, 1938, 189, point to this creative process. The monochrome work *Alphabet II* (fig.) reveals a further step toward the printed and arranged text. On a sheet of newspaper printed with private advertisements, the letters of the alphabet—the smallest elements of a text—appear to have been thrown down with loose brushstrokes, in no particular order.

The reverse process, the dissection or breaking down of signs into particles, is seen in *Zerstörtes Labyrinth (Destroyed Labyrinth)* (fig. p. 103). A plan created by man

Alphabet II, 1938, 188 (M 8)
Colored paste on newspaper on cardboard
49 x 33 cm
Zentrum Paul Klee, Bern

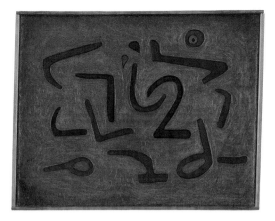

is destroyed along with its principle of order. The process of dissolution removes the fear of the hopelessness—and ultimately, death—contained in the labyrinth. We are not looking at fragments of a ruin as symbols of the past; rather, they are constituents of a new beginning from the dialectics of destruction. Klee was economical with his artistic materials here: on a fiery red background painted with coarse brushstrokes we see isolated red-brown, bar-like elements vaguely reminiscent of letters or numbers—but which also resemble shapes from nature, such as the teardrop-like structures at top; or the ovum-like circle to the right. Each element moves freely in space, without touching the others; nevertheless, they stand in relation to one another and adapt to their neighboring forms. They are part of a whole; basic elements of a cosmos being created and which still appear to be seeking their place and form. A lava-like substance serves as their base. The warmth and energy of the magma is the source, the chaos, from which the new can develop. This is in keeping with a note Klee made during his Bauhaus period: "Chaos is a disordered state of things, a confusion. 'World-creatingly' (cosmogenetically) a mythical original state, from which slowly or suddenly, spontaneously or by the act of a creator, the ordered cosmos is formed."

With reduced artistic means, the focus on one color and the use of simple forms, Klee is able to build a bridge from destruction to construction—thereby creating symbols for the cycle of life. EWS

Zerstörtes Labyrinth, 1939, 346 (Y 6)
Destroyed Labyrinth
Oil and watercolor on oil priming on paper
on burlap on stretcher; original frame strips
54 x 70 cm
Zentrum Paul Klee, Bern

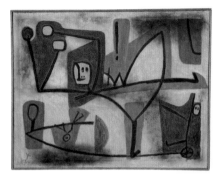

High Spirits

A figure leans far back—its three arms truncated like drumsticks—and balances precariously on one leg above the tightrope. Its facial expression is bold and decisive, the exclamation mark above the balancing act and red fields around the head and upper body accentuate the extraordinary moment. In the large-format painting *Uebermut (High Spirits)* (fig.) Paul Klee returned to the theme of balance which he had dealt with theoretically and in his work in the twenties. In his 1921 Bauhaus-period "Beiträge zur bildnerischen Formlehre" (Essays on Artistic Form), Klee described the motif of the tightrope walker and balancing pole as the "most extreme realization of the balance of forces" (see pp. 74–75).

Eighteen years later, that became a risky dance on the high wire—the tightrope walker and the tightrope, which, like a taut bow, stand up to the forces acting upon them. Below the tightrope walker, another small figure on a blue field of color seeks to avoid tipping over and falling by clinging onto the short, pole-like extension of the rope. At bottom right, a third artiste appears on a unicycle. Klee used the motif of the precarious balancing act in two earlier works, *Wieder kindisch (Childish Again)*, 1939, 750, and *Blauer Tänzer (Blue Dancer)*, 1939, 852. In *High Spirits*, it takes on a symbolic dimension: the figure of the tightrope walker and drummer becomes a metaphor for Klee's own endangered artistic career. Klee said in 1940 that during intense work he had the feeling of beating a drum. *High Spirits* could be read in the context of Germany's invasion of

Uebermut, 1939, 1251 (PQu 11)
High Spirits
Oil and colored paste on paper on burlap
on stretcher; original frame strips
101 x 130 cm
Zentrum Paul Klee, Bern

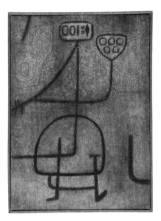

Poland—as a parable on the "eternal drummer" Adolf Hitler and his "high spir-
ited" war. This is supported by the fact that *High Spirits* contains motifs from
Francisco de Goya's etching *Que se rompe la cuerda* from the *Los Desastres de la
guerra* series—which portrays the arrogance of the Spanish Church in the war
against Napoleon—as well as motifs from Pablo Picasso's 1937 cycle of etchings
Dream and Lie of Franco. Both show their subjects under attack—as overconfi-
dent tightrope walkers, proud before a fall.

By contrast, *la belle jardinière (Ein Biedermeiergespenst)* (fig.) is an image of sur-
real brightness. The schematic figure of the title, constructed of red and blue lines,
wearing a hoop skirt and labeled ironically as a "beautiful gardener," is holding
a bouquet of flowers in her upraised left hand. The color composition is com-
parable with that of *High Spirits*, which appears shortly after it in Klee's *oeuvre*
catalogue. Klee achieved a pronounced three-dimensional color effect with the con-
trast between the rich, intensely colored lines of *la belle jardinière* and her pale
background. The colors fluoresce on the irregular white priming on the burlap.
Klee based this figure on his pencil drawing *Mit Blumen (With Flowers)*, 1939, 766.
The figure holding the flowers in that work consisted of only a few lines; Klee
built her up—probably starting with the big eyes—into his spectral *jardinière*. She
appears as a Biedermeier ghost, a magic, shining phantom. Perhaps the title takes
a shot at the Nazis' concept of art, which idealized nineteenth-century aesthetics,
using it as a yardstick for modern art, which they decried as decadent. AS

la belle jardinière (Ein Biedermeiergespenst),
1939, 1237 (OP 17)
Oil and tempera on burlap on stretcher;
original frame strips
95 x 71 cm
Zentrum Paul Klee, Bern

Blue Flower

blaue Blume (Blue Flower) (fig.) was created in 1939, Klee's last full year of work-
ing but which was far more productive than any previous year. Schematic leaf
and flower motifs stand out on a deep, dark blue background; at center, a black
contoured leaf-like form with lobe-shaped, serrated bulges; at bottom right, a
flower on a stem. More, smaller, flowers appear to extend beyond the edges of the
painting. The depth of blue in the background contrasts with the flat floral pat-
tern. Klee spent a great deal of time exploring the psychological effects and sym-
bolism of blue. Thinking of the sky or of water, the observer is placed into a
meditational blue space, whose dusky tonality communicates something secretive
and melancholy.

Representations of plants, gardens, and parks are very important in Klee's *oeuvre*.
The artist's relationship with nature goes far beyond the traditional study of nature,
encompassing the interplay of nature, man, art, and creation in its entirety. To
Klee, botanical motifs do not hold the tranquility of a natural idyll; they have their
own sphere of meaning. His belief in the continuity of life and the self-renewing
forces of nature finds its expression in his portrayal of plants. The image of the
delicate blue flower next to the large, serrated formation of leaves also represents
the duality of good and evil. In contrast to other works, it is not growth and fer-
tility to the fore here; rather, this painting is about the threatening aspect of nature
and its vulnerability.

blaue Blume, 1939, 555
Blue Flower
Watercolor and tempera on oil priming
on cotton on plywood
50 x 51 cm
Zentrum Paul Klee, Bern, Livia Klee Donation

The title *Blue Flower* refers to one of the most powerful symbols of the German Romantic movement. The blue flower stands for the world which the rational cannot grasp and the Romantic yearning for eternity. In the 1802 literary fragment *Heinrich von Ofterdingen* by Novalis, the hero falls under the spell of a blue flower, which appears to him as the goal of his spiritual aspirations and the symbol of love. Immediately before *Blue Flower,* the ailing artist entered *tief im Wald (Deep in the Wood)* in his *oeuvre* catalogue under the number 1939, 554. *Deep in the Wood* is done in shades of green and similarly shows schematic, precise plant motifs. These two works in almost identical format are a matching pair, and refer to Novalis. A look at the text offers a parallel: "At last, as morning drew nigh and dawn broke outside, his soul became calmer, clearer, and the images became more lasting. It seemed to him as if he were walking alone in a dark wood." Novalis continues: "But what drew him with all its power was a tall, light blue flower, which stood by the spring and touched him with its broad, shining leaves. All around it stood countless flowers in all colors, and the magnificent smell filled the air. He had eyes for nothing but the blue flower, and gazed long at it with unutterable tenderness."

Klee's affinity with German Romanticism was a matter of personal philosophy; he described his style as "cool Romanticism," and Romantic motifs such as the moon and stars, dreams and imaginary journeys, genies and angels become the focus of themes running through his work from 1918 onward. MBA/CLU

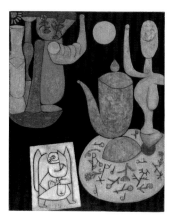

"The Last Still Life"

This painting was among those left in the artist's Bern studio in Kistlerweg after his death. Felix Klee subsequently called it "the last still life," a description which has become its title. A photograph shows that the ailing artist had largely completed the picture in 1939, but that he later reworked it and added to it.

In *Letztes Stillleben (The Last Still Life)* (fig.), the classic props do not confirm or symbolize the order of the world—they twist it in the ironic sense and turn it around. In its duality of poetic meaning, the work is a summation of Klee's imaginings, in which he allows the motifs of his final years to parade across the canvas: for one last time, the *Engel, noch hässlich (Angel, Still Ugly)* eyes us from bottom left (it is based on Klee's drawing of the same name, 1940, 26), while the archaic statuette with a raised arm appears to wave to the observer. The flower-covered orange circle upon which it stands could be a bowl, or it could be the light of the moon.

The double meaning of the painting can also be understood literally; that is, as a turning-around of normal orientation. Seen from the usual perspective, one thinks one sees four vase-like containers with two red flowers at top left. But turn the painting around, and the "vases" are transformed into a kind of fairytale wood with a large red toadstool. The two "flowers" turn into two stick figures on unicycles, trying with difficulty to keep their balance. They have their origins in a drawing from 1939 (Klee's most productive year as an artist), which Klee titled

Ohne Titel (Letztes Stillleben), 1940
Untitled (The Last Still Life)
Oil on canvas on stretcher
100 x 80.5 cm
Zentrum Paul Klee, Bern, Livia Klee Donation

vergesslicher Engel, 1939, 880 (VV 20)
Forgetful Angel
Pencil on paper on cardboard
29.5 x 21 cm
Zentrum Paul Klee, Bern

Fliehn auf Rädern (Fleeing on Wheels), 1939, 653. A strange, caterpillar-like creature bends over these imps, half unipede, half genie, and appears to be watching them.

With these references to drawings from the years 1939 and 1940, the painter indicates—in one of his last paintings—how important his graphic art is to his *oeuvre*. The drawing does not have a subservient role, and is only in rare cases a sketch or rough draft—rather, it is an independent means of artistic expression. In the late work, drawing as a serial process undergoes a metamorphosis of meaning. Closed series of works are created, which Klee makes recognizable with titles like *Engel (Angels), Inferner Park, Näherungen (Approaches), Eidola, Urchs, Fusswaschung (Foot Washing)*, or *détaillierte Passion (Detailed Passion)*. Especially popular is the group of works of the thirty-five angels, which with all their shortcomings appear very human in an amusing sort of way. Thus, we do not meet just the angel "still ugly," we also find the "precocious" and the "forgetful" angels (fig. p. 108). On one occasion, the angel appears as a fool—*Schellen-Engel (Bell Angel)* (1939, 966)—or is still "in kindergarten," and now and again he has a crisis, as in *Krise eines Engels I (Crisis of an Angel)* (1939, 1021). By Klee's own definition, his angels are figures "in the waiting room of angeldom," human creatures carrying out their "final acts on Earth," so as to soon "take wing" as angels. Seen thus, they are symbols of transition, reflecting the gravely ill artist himself. MBA

Paul Klee in the music room at Kistlerweg 6,
Bern, 1939

"Our Knowledge of an Object's Interior Makes it Greater than its Outward Appearance"

"For the artist, the dialogue with nature remains *conditio sine qua non.*" Thus wrote Paul Klee in his 1923 essay *Wege des Naturstudiums* (Paths in the Study of Nature). The wealth of forms and structural principles in nature make up the foundations of Klee's *oeuvre*—not in the sense that he imitates them, rather, he is inspired by nature's structural regularity.

While teaching at the Bauhaus, Klee had his students analyze, for instance, the structure of leaves or cross-sections of snail shells for "guidance into the very essence" of things. He noted in *Wege des Naturstudiums:* "The object expands beyond its appearance through our knowledge of its interior," For Klee, an intense observation of nature had a metaphysical dimension—by observing nature, the artist raises himself to the state of mind which allows him to freely create his works in an analogy of the divine process of Creation.

Klee's studio was crammed with a wealth of objects which he had gathered on his walks and travels. They included plants and stones, lichens and mosses, as well as all the various treasures which became the basis of his collection of natural objects. Klee made a precise classification of the plants he collected, pressed them, and carefully collated them in a herbarium (fig.).

In order to recreate the variety and wealth of nature in his art, Klee experimented with materials such as plaster, chalk, and sand, which he worked into the primer.

He even made his own tools for this purpose, and used found objects, such as shells, bones, and potshards as containers to hold or mix paint in—alongside the more conventional commercial ones (fig. p. 110).

Klee's students at the Bauhaus regarded his studio as a kind of sorcerer's kitchen, in which the master mixed up his "recipes" (fig.). One Bauhaus student, the Swiss artist Hans Fischli, looking back on his time there, wrote: "Large clay pots stood on the table, filled with lots of clean paintbrushes; bottles of solvent, binder, oil, and lacquer. We saw what kinds and what brands of paints he used, nor did he hide his many types of quality paper. We looked into his kitchen, he didn't need a cookbook, he had his recipes which he altered and remixed, according to time and need. Many called Paul Klee a magician, and they still do—but he wasn't, he didn't do magic. He was a discoverer, who found magic things. Doing magic is honest cheating done by illusionists. Klee pictures never lie." MBA

reconstruierte Scherben, 1939, 101 (L 1)
Reconstructed Shards
Colored paste and watercolor on newspaper
on cardboard
28 x 17.5/17.1 cm
Zentrum Paul Klee, Bern, private loan

Paul Klee's studio in Weimar,
first half of 1926

The "Pedagogical Estate": Paul Klee as a Teacher at the Bauhaus

Michael Baumgartner

"I believe the most important thing [...] is to call upon an artist to be a teacher whose art is living and contemporary enough to be a guide to youth."
Paul Klee in a letter to Oskar Schlemmer, July 2, 1919

Paul Klee taught during his ten years at the Bauhaus, from 1921 to 1925 in Weimar, and from 1925 to 1931 in Dessau. He was called to be a master at the Bauhaus by Walter Gropius in October 1920. The founding of the Bauhaus was based on the utopian idea of a "construction of the future," in which the arts and crafts would combine into a single creative unit. In line with its motto, "school should ultimately culminate in the workshop," the artists were master craftsmen in charge of their workshops.

Klee began his teaching career in January 1921 with the introductory course, and at the same time headed the bookbinding workshop. Later, he was in charge of the studio for glass painting and of the textiles workshop.

The development of a theory of artistic form and design was at the core of his teaching, but he also stressed the importance of its intellectual foundations. He was not so much interested in communicating knowledge; rather, he wished to point out the links between the laws governing artistic creativity and the formative processes in nature.

Klee's teaching methods were systematic and objective-driven. An extract from a letter to his wife Lily makes it clear that he prepared painstakingly and structured his lessons clearly from the very beginning: "The lecture yesterday went well; once more I was prepared down to the last word and didn't have to worry that I might say anything less than responsible."

The teaching material from Klee's Bauhaus period includes his earliest lectures from the years 1921/22 and more than three thousand manuscript pages of what has been termed the pedagogical estate, making it possible to take a comprehensive look inside Klee's artistic philosophy and his theory of art. When the artist left Germany in 1933, he had this material sent on to him in a trunk. After his death, Lily Klee and the art history student Jürg Spiller went through it and published extracts of it in the volumes *Das bildnerische Denken* (The Thinking Eye, 1961) and *Unendliche Naturgeschichte* (The Nature of Nature, 1974).

Klee collected his preparation for lessons in the winter semesters of 1921/22 und 1922/23 in a bound volume with 192 numbered pages under the title *Beiträge zur bildnerischen Formlehre* (Contributions to a Theory of Pictorial Form). The most

The handwritten manuscript page (no. 131) contains German handwritten text with figures 12, 13, and 14.

Beiträge zur bildnerischen
Formenlehre
Contributions to a Theory
of Pictorial Form
Finite and Infinite Motion
Weimar, Lecture on
April 3, 1922
Zentrum Paul Klee, Bern

important sections are the introduction to the basic elements of design—point, line, and area—and an analysis of their application in the artistic work process. Questions of balance, structure, and division of the design elements are central, as is an introduction to tonality and the theory of color. Klee's understanding of design in these essays is processional and dynamic. The elements of form are regarded as forces with the potential of movement in them (fig.). The dated manuscripts in the collection of essays and the lectures that go with them make it possible to reconstruct an almost complete picture of Klee's teaching from November 1921 until the summer of 1925 in Weimar.

The pedagogical estate, more than three thousand teaching manuscripts from 1925 to 1930 at the Bauhaus in Dessau, proves to be far more complex. This heterogeneous material is far wider-reaching and contains theoretical records and sketch-like entries as well as precise geometrical constructional drawings. Even while he was teaching at the Bauhaus, Klee began to sort out these comprehensive materials and to think about a structure for them. All these records mean that we can, with a high degree of accuracy, reconstruct his grand project of an "artistic theory of design" and a "planimetric theory of design."

Blattformen
Shapes of leaves
PN10 M9/5 (Principal Order)
Lecture on October 23, 1923
Black ink on paper
Zentrum Paul Klee, Berne

According to the table of contents drawn up by Klee, the "theory of artistic design" was made up of three main chapters: "Principal Order," "Special Order," and "Structure." The subject of "Artistic Mechanics" was to be published separately. In his "Principal Order," Klee examined the connections between the rules governing art and the laws of structure in nature. This included the analysis of the different types of shapes and structures of leaves as well as analogies between organic growth and the artistic processes which lead to the creation of form (fig.). To illustrate his point, Klee drew parallels with the growth of plants from seeds to the formation of fruit, looked into the circulation of blood and tectonic layers, the water cycle, as well as many other processes of movement found in nature. While the "Special Order" chapter dealt with the creation of images in two and three dimensions, using techniques of sliding, turning, and reflecting, Klee used his "Structure" chapter to develop his fundamental principles of artistic creation in an analogy with music. For Klee as an impassioned violinist and music lover, rhythm and polyphony came first and foremost. In his notes on rhythm, for instance, Klee transposed musical time (two-four, three-four, six-four time, etc.) into structured

sequences, or into rhythmically structured two-dimensional patterns (fig.). Instead of using lines as structural elements, colors are often employed to keep or to change the "beat." In this way, homophonic creations are built upon by the addition of multiple layers—turning them into polyphonic images.

In his "Artistic Mechanics," Klee looked at questions of movement. He emphasized points of thematic importance such as forms of bound and of free (cosmic) motion, the different kinds of movement in man and animals—which is dependent on the construction of the body and on the medium through which it moves (over land, through water or air)—and studied the states of balance and imbalance.

The largest and least known of Klee's pedagogical estate are the nineteen chapters—2,300 pages—on "Planimetric Design." It consists mainly of geometric construction drawings and dates almost exclusively from Klee's time as a teacher in Dessau—the Bauhaus period in which the technical-constructive orientation began to gain in importance.

Vierstimmige Polyphonie
Four-part Polyphony
PN5 M4/95 (Structure)
Undated
Graphite and color pencil
on paper
Zentrum Paul Klee, Bern

Rotationsbewegungen mit
"Innenschemata"
Rotating Movement with
"Patterns Inside"
PN7 M6/589 (Planimetric Design)
Undated
Color pencil on paper
Zentrum Paul Klee, Bern

In his "Planimetric Design," Klee analyzed the artistic possibilities for construction using the elementary geometric forms of the square, triangle, and circle, and he investigated the possibility of incorporating them into the process of creating dynamic images. Two important aspects of this process of "dynamisation" are what have become known as the progressions and rotations, which are played out in countless variations in a chapter all to themselves (fig.). Klee drew his creations with the greatest geometrical precision; all his normative geometry was merely the means to an end. What he was really interested in were the "unreal" constructive possibilities created by deviations from the rules.

Letters and Writings at the Zentrum Paul Klee

Michael Baumgartner

Paul Klee's writings are a treasure which, although less spectacular than the collection of works, are of no less importance when it comes to understanding and researching the life and work of the artist. The Zentrum Paul Klee has a comprehensive collection of Klee's writings, chiefly thanks to a generous donation by the Klee family, and an important permanent loan by the Bürgi family; and the Paul-Klee-Stiftung added its collection. The archive contains thousands of manuscripts. They include Paul Klee's diaries, his handwritten *oeuvre* catalogue, manuscripts of lectures, poems, various pocket calendars, and more than five thousand letters which make up the correspondence of Paul and Lily Klee with family members, artist friends, gallery owners, museum people, and many others. Among the handwritten documents are school notebooks and books from Paul Klee's personal library, with sketches and notes which the artist put in the margins, as well as three thousand pages of the "pedagogical estate," which contain a record of his lectures, teaching notes, and his ideas on the theory of art at the Bauhaus (see pp. 112–116).

The hand-written *oeuvre* catalogue consists of a total of four notebooks and six ring binders which are not consistent in their outward appearance or inner structure. In February 1911, Paul Klee decided to keep a catalogue of his works to that time, including his childhood drawings. From that point on, he wrote down and numbered his artistic production with unprecedented bookkeeping precision. When he was gravely ill in May 1940 and went to the Tessin for a rest cure, he had brought his *oeuvre* catalogue up to number 366—symbol of a complete year's production in the leap year of 1940. The *oeuvre* catalogue was for Klee a means to keep track of, and to maintain order in, his artistic production throughout his career as an artist. While in the early years he restricted himself to allocating numbers, dates, titles, and descriptions of technique to his works, in the years that followed, he made his entries more systematic and developed an increasingly complex system of classification. From 1918 (there are records of sales from before 1918) he began to develop clearer categories, unified his technical terminology, and, at the same time, kept a record of sales and prices. From 1925, the artist introduced encoded numeration so that the numbers put low on the cardboard onto which the works are mounted, along with the title, did not allow people to draw any conclusions as to the quantity that his yearly production had reached (fig. p. 118). The importance of the hand-written *oeuvre* catalogue to Klee is evidenced by the fact that during the First World War, he was apparently so worried the

original would be lost that he had his friend Sasha von Sinner make a copy, which he continued with and completed.

Paul Klee's diaries comprise four notebooks as well as several additional autobiographical manuscripts. These records begin in 1898—with entries formulated retrospectively back into early childhood—and end at the conclusion of the First World War in 1918. The diaries are not intimate journals—rather, they are texts which have been minutely reworked and retrospectively edited, in which Klee sheds light on his own thoughts. He compiled them from his original diary entries (of which only fragments remain) and from extracts to his letters to his fiancée and later wife, Lily Stumpf, and subsequently filled them out. The diaries are rather like an actual autobiography, in which the artist portrays his own career as the story of his artistic development.

The largest portion of Paul Klee's hand-written documents is the more than five thousand letters and postcards provided by the Klee family, private collectors, and the Bürgi Archive in Bern. They are, on the one hand, Klee's letters to Lily Stumpf, to his parents, and to his sister Mathilde, as well as letters and copies of letters to friends and fellow artists, to collectors, museum curators, art critics, gallery owners, and many others; on the other hand, the collection includes their replies. Thanks to intense effort, the Paul-Klee-Stiftung was able to compile complete correspondences after searching for Klee's letters in archives and among personal effects around the world. Among Klee's most important correspondents were

Paul Klee's oeuvre catalogue, 5,
entries for 1932, nos. 261–280
Zentrum Paul Klee, Bern

Skeleton of the eagle, from
Zoology notebook II: birds
(Aves), 1894
Zentrum Paul Klee, Bern,
on permanent loan from
private collector

the artists Wassily Kandinsky, Alfred Kubin, Franz Marc, and Emil Nolde, the art
historians Carl Einstein, Will Grohmann, and Wilhelm Hausenstein, the collectors
Ida Bienert, Hanni Bürgi-Bigler, Otto Ralfs, and Emmy "Galka" Scheyer, as well
as the art dealers Katherine Dreier, Alfred Flechtheim, Hans Goltz, Karl Nieren-
dorf, Rudolf Probst, Curt Valentin, and Herwarth Walden. Only a tiny portion of
this rich correspondence has been put into published form. Of particular interest
are the letters and postcards onto which Klee or the artists he knew put illustrations.
Numerous notebooks and illustrated schoolbooks from Klee's days at the Städtische
Literarschule in Bern from 1891 to 1897 offer an impression of the artist's early
imagination and drawing talent. They have been made available to the Zentrum
Paul Klee by means of a permanent loan from a private collector. While the careful-
ness and precision of the drawings in the anatomy and zoology notebooks is im-
pressive (fig.), the drawings and jottings in the margins, with which the pupils got
through the boredom of lessons, are fascinating in their wit and in their author's
obvious relish for the grotesque (fig. p. 120).

While the diaries until 1918 offer a comprehensive insight into Klee's thoughts, his
personal writings after 1920 are disparate and only in a few places do they provide

Drawing in the margin of
Paul Klee's school book
Analytische Geometrie,
1898, p. 130, "einsam in
trüben Tagen ..." (lonely on
bleak days ...)
Zentrum Paul Klee, Bern,
on permanent loan from
private collector

clear information about Klee's ideas. That makes the five pocket diaries from the
years 1926 to 1935 all the more interesting, as Klee often used them to make short
diary-like entries, sketching out themes for his lessons at the Bauhaus as well
as spontaneous ideas, puns, even recipes. For January 10, 1935, Klee—a lover of
quality country cooking—made a note of the following menu: "goulash, elbow
noodles, cauliflower salad, salt, and pepper. Ingredients: not too much onion, not
too much garlic, finely chopped celery, leek, finely chopped horseradish, tomato
purée, parsley, apple, a few carrots, no marjoram this time, a dash of red wine to
finish it."

Paul Klee's written documents are, like his library and *oeuvre* catalogue, available
for viewing free of charge by researchers and interested members of the public
at the Zentrum Paul Klee.

Music at the Zentrum Paul Klee

Kaspar Zehnder

Paul Klee as a Musician

Paul Klee's love of music began at home: his father, Hans Klee, was a music teacher at the Staatliches Lehrerseminar (State Teachers' Seminar) Hofwil/Bern, and his mother Ida Marie was a singer. Even as a youth still in school, Paul Klee played volin at the Bernische Musikgesellschaft (Bern Music Society). After finishing school in 1898, he was undecided whether to become a musician or a painter. He described music as his mistress, while painting was his wife, who he was sensible enough to stay with. During his art studies in Munich under Heinrich Knirr and Franz von Stuck, Klee played regularly and moved in musical circles. He met his future wife, the Munich pianist Lily Stumpf, at a musical gathering in 1899. Following his stay in Rome, Klee returned to his parental home in 1902. He earned his living once more as a violinist at the Bernische Musikgesellschaft. A key musical experience was a performance in Bern of Jacques Offenbach's *Les Contes d'Hoffmann* in the new city theater. Klee sensed a spiritual affinity with the composer in the admixture of solemnity and playfulness, fairytale and satire, earthly and celestial spirit in Offenbach's work.

Paul Klee's great passion was opera. He was a regular operagoer wherever he lived, and a connoisseur of the entire classical and romantic repertoire from Mozart to Bizet and Debussy, all the way to the dramatic works of Leoš Janáček, Modest Mussorgski, and Richard Strauss. His view of Wagner and Verdi was less problematic than his many isolated critical notes have led people to suppose; he appreciated the work of both composers and particularly loved their last operas, *Parsifal* and *Falstaff*.

In his letters and journals, Klee often made enthusiastic—and not infrequently, critical or even sarcastic—comments on the quality of performances. He was particularly hard on the Bern music scene, whose offerings he regularly tore to pieces in his diaries or as the music reviewer of the *Bernisches Fremdenblatt*.

Klee was an interested but distant observer of the evolution of modern music. He was in contact with Béla Bartók, Paul Hindemith, and Arnold Schönberg, but never played their works—perhaps because he was too critical of his own playing to venture the new techniques required. He was always skeptical of twelve-tone music, finding it contrived, made up of too much rationalism and too little art. As Klee saw it, musical abstraction had been perfected in the works of Bach and Mozart, and required no further development.

Klee's love of Mozart was summed up by Karl Grebe, a fellow musician and friend,

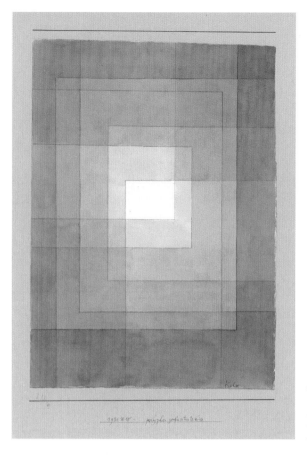

polyphon gefasstes Weiss,
1930, 140 (X 10)
White Framed Polyphonically
Pen and watercolor on paper
on cardboard
33.3 x 24.5 cm
Zentrum Paul Klee, Bern

as follows: "It would be pointless to talk about Paul Klee as a musician without talking about Mozart, because Paul Klee's musical world view was clearly focused on that master. [...] His playing of Mozart lead directly to the heart of the matter—if we can describe the essence of Mozart as a combination of demon, esprit, and sensuality, then we can establish a true relationship between the musician Mozart and the painter Klee."

Klee's paintings and drawings contain a wealth of iconographic references to music *(Musiker [Musician], alter Geiger [Old Violinist], Sängerin der komischen Oper [Singer of the Comic Opera])*. Klee was spellbound by the possibilities of combining musical associations with levels of imagery found in painting *(Fuge in rot [Fugue in Red], Landschaft in A dur [Landscape in A Major], polyphon gefasstes Weiss [White Framed Polyphonically]*, fig.). Going beyond this, we find musicality is one of the key formative criteria in the Klee *oeuvre*, in his artistic philosophy, and in his theoretical and didactic writings. The composition, rhythm, and melody

aspects of many of his paintings and drawings are musically oriented, parts of the theoretical foundation of his work and his teaching are clearly constructed on musical and tonal elements. Certainly, some of his works can be freely interpreted as musical scores. Yet in his 1928 essay *Exakte Versuche im Bereiche der Kunst* (Precise Experiments in the Field of Art), he admits: "What was achieved in music by the end of the eighteenth century, is (for the moment) still in its beginnings in the area of painting."

Klee's artistic quest to use music reached its zenith in his application of polyphonic musical composition processes in which the superimposition and penetration of different fields of color create a "polyphonic" structure in the paintings.

The Music Program at the Zentrum Paul Klee

The link between the fine arts and music was important to the museum's founding families, the Müllers and the Klees, and it is of central importance for the Zentrum Paul Klee philosophy. The auditorium has space for three hundred people, and provides the architectural backdrop for concerts and events. With its music program, the Zentrum Paul Klee aims to address a traditionally musical audience as well as a new generation of music lovers, giving them access to a further dimension of Paul Klee's artistic thought. Paul Klee's artistic, literary, and theoretical works influenced the music of his contemporaries and their successors like no other artist.

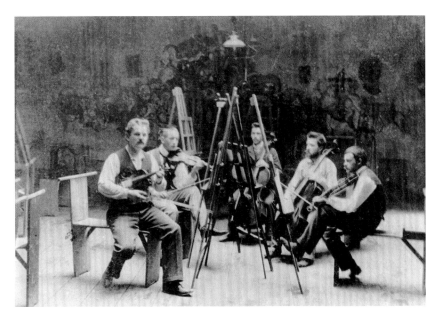

Quintet in the studio of Heinrich Knirr's art school, Munich;
on right Paul Klee, first violin, 1900

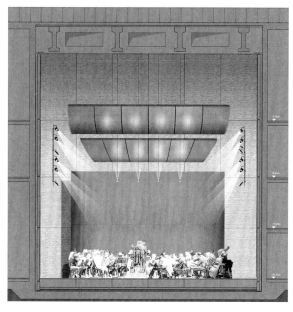

The auditorium of the Zentrum Paul Klee

The Zentrum Paul Klee has a comprehensive, academically revised archive containing more than 250 scores and some 170 recordings of compositions which refer to Klee's work or which were inspired by it.

The Ensemble Paul Klee

For the interpretation of its musical objectives, the Zentrum Paul Klee has gathered its own ensemble, the Ensemble Paul Klee, a loose group of between eight and fifteen musicians distinguished by their clear line in their programs and an unmistakable signature. The compilation of the ensemble's program is focused on Paul Klee, even if the reference is sometimes merely indirect.

The Ensemble Paul Klee distinguishes itself in a series of productions at the center—not just concerts, but also music which communicates to visitors, both in spontaneous encounters and in the greater debate on the actualities of the themes, space, and time dealt with here. This includes productions put free of charge on the Museum Street at the Zentrum Paul Klee under the motto "street music—miniatures, improvisations." They are inspired by the Bern tradition of cabaret and public musical performance, play upon the nearby autobahn which so strongly influenced Renzo Piano's architecture, and underline the significance of the Museum Street as a promenade and a place to see and be seen. Musical creations on the Museum Street may also be heard in other parts of the complex, such as in the children's museum Kindermuseum Creaviva and the exhibition rooms.

A further format is the "twenty-minute concert" for the synaesthetic benefit of the visitor. These mini-concerts offer insights into the ensemble's current musical work and make it possible to experience the internal connections between music and painting. They take place in the exhibition rooms during opening hours and feature music Klee loved, music by his contemporaries, and music which contains references to Klee's work or is inspired by it.

Visiting Ensembles

The Ensemble Paul Klee plays host to national and international ensembles of similar intent and artistic aims. Groups playing for Bern audiences at the Zentrum Paul Klee will include the Ensemble Intercontemporain, the Ensemble Modern, the Ensemble Phoenix, the Klangforum Wien, and the Ensemble Contrechamps. A special mention is due to the Camerata Bern, a fourteen-person string orchestra which has performed all over the world as a musical ambassador for Switzerland. The Camerata Bern is the partner ensemble of the Zentrum Paul Klee and performs its own concert series for subscribers at this location.

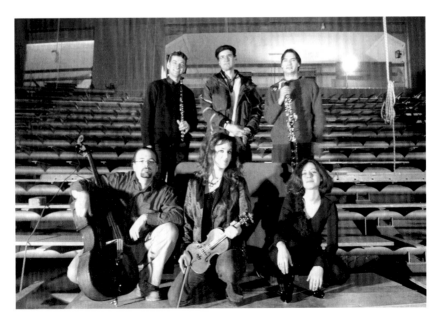

The Ensemble Paul Klee

The Children's Museum: Kindermuseum Creaviva

Adrian Weber

The discovery of the child's expressiveness as a model for all creativity was an important one for Paul Klee in his quest to find his true artistic desire. In February 1911—a year before Wassily Kandinsky and Franz Marc propagated the images made by "primitives" as the model for modern art in the 1912 *Der Blaue Reiter* almanac—Paul Klee started an *oeuvre* catalogue of his artistic production. The first entries were eighteen childhood drawings—thereby given the status of works of art.

Paul Klee's son Felix was born in 1907, and Klee entered the cosmos of original creativity once more. He kept Felix's drawings, looking to them for inspiration for the rest of his life. In a 1911 review on the first Blauer Reiter exhibition in Munich for the Swiss culture magazine *Die Alpen*, Klee wrote: "There are primeval origins of art, as they are found in ethnographic collections or at home in the nursery. Do not laugh, reader! Children can do it too, and there is wisdom in the way that they do it! The more helpless children are, the more valuable are the contributions they offer us, and one must protect them from corruption at an early age."

The establishment of the Kindermuseum Creaviva at the Zentrum Paul Klee is based on the significance of children's creativity in the artistic philosophy of Paul Klee. Therefore, the activities focus on the overall creative process—art is to be experienced through playful research using the five senses. The driving force is curiosity, which makes us seek and discover beauty in the world so we can recognize ourselves.

The Rooms

The Kindermuseum Creaviva occupies seven hundred square meters in the North Hill. The route into the first lower level takes visitors from the Museum Street down two flights of stairs or an elevator. The large room stretches along the glass façade. It is made up of three studios. The reception desk for visitors is integrated into them. Nearby are a reference library and computer terminals.

There is also a photo laboratory and a ceramics kiln. In fine weather, there are other possibilities for creative development, such as the landscape sculpture of the grounds, and the Sculpture Park at its edge.

Horse and carriage
Pencil and chalk on paper with red lines
from a cash book on cardboard
10.6 x 14.7 cm
Zentrum Paul Klee

A Children's Museum

The world's first Children's Museum was born in Brooklyn, New York, in 1899. Today, a children's museum is understood to be a place where children can explore the world around them. "Hands-on" and "learning by doing" are the watchwords, and the aim is to awaken and promote curiosity and creativity. The didactic orientation of the Kindermuseum Creaviva concentrates on one artist. As an integral part of the Zentrum Paul Klee, the children's museum is able to exploit the center's many synergies. The name "Creaviva" was chosen from among many suggestions. It links *creare* (Latin for to create or to make) with *vivere* (Latin for to live or to experience), and this meaning can be understood internationally. It points to the comprehensive and integrative idea behind the museum—which is not just open to children, but is aimed at people of all ages.

In June 2002, Maurice E. Müller and his daughter Janine Aebi-Müller established the private body, the Fondation du Musée des Enfants auprès du Centre Paul Klee and set out its philosophy. The Kindermuseum Creaviva aims to do justice to the artistic universe of Paul Klee, and will focus on schooling all the senses—as a counterweight to the purely utilitarian, to consumerism, and passive media reception. The children's museum considers itself a future-oriented institution which

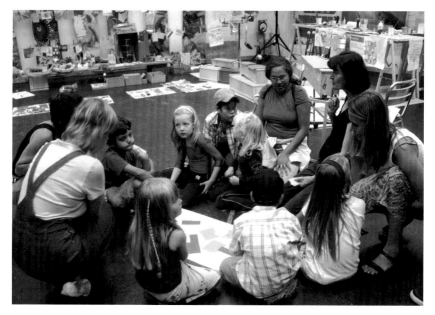

Workshop in the Kindermuseum Creaviva

draws on the wisdom of the past and creates relevant links with the future. It aims to be a place where every human being can unfold, where perception, interpretation, and understanding can be questioned from various standpoints. Ultimately, the Kindermuseum Creaviva wants to encourage visitors to find their own answers to their questions. In the middle term, it also plans to become a center of competence for art education. To achieve this, it is promoting close cooperation with tertiary institutions, art museums, and children's museums nationally and internationally with symposia and further training seminars.

Workshops—"Open Studio"

The Kindermuseum Creaviva is able to use the resources of the Paul Klee Collection, the comprehensive multimedia database, the research department, and the everyday happenings at the Zentrum Paul Klee. The activities it offers are based on these resources:

A free choice of interdisciplinary topics linked to Paul Klee and the center's architecture are open to visiting groups. School groups—and groups of adults—can arrange their own program in advance in consultation with the studio directors. In the regular program for children, young adults, and adults, one area will be explored in depth. Longer, one-off projects will run during the school holidays. During the opening hours of the Paul Klee Collection, there is an "open studio" available for spontaneous visits, pointing out the relevance of the artist to the visi-

tor today and applying it in practice in the studio with the help of experts. The program targets people from the ages of four to ninety-nine. A meeting of different age groups is part of the philosophy.

In-Depth Exploration

Aspects of the collection of the Zentrum Paul Klee are taken up in a modular system of information cards. Along with an introduction to the topic, individual works are discussed. A third element suggests methods of practical application in the studio. The modules are continually developed and are therefore a multifunctional tool in the studio as well as in the classroom and at home.

Exhibitions, Events, and Guided Tours

In its two hundred square meter "loft," the Kindermuseum Creaviva presents a didactic exhibition focusing on one aspect of the permanent Klee Collection. This exhibition is open to the general public, in a constant state of change, and lives from the people who visit it. The exhibition is completely overhauled every six months.

Musical concerts, theatrical and dance performances, readings, film showings, and special tours are specially announced, inviting young people to keep coming back. And we employ a concept successfully introduced to Switzerland with the Rosengart Collection in Lucerne, and the Kindermuseum Creaviva builds upon it: children guide others of their age through the collection.

Collecting and Research

The Kindermuseum Creaviva has its own didactic collection of children's drawings. It is based on the donation by the St. Gallen education specialist Hans Hochreutener, this collection is being scientifically researched, and is open to teachers—and on occasion, to the wider public.

Publications

The Museum Shop offers in-house and specially designed publications aimed at younger visitors. A *Creaviva Journal* is published regularly. Current information available on our home page: www.creaviva.zpk.org.

Museum Street and Visitor Communication

Ursina Barandun

The Zentrum Paul Klee is different from traditional art museums. It offers an inter-disciplinary approach to art and culture, and is clearly oriented towards its visitors. Art is communication. Art needs a dialogue with its audience, and an interested audience seeks this dialogue. To this end, many visitors want to see additional information—which the Zentrum Paul Klee is happy to provide. Visitors can decide for themselves whether they want to take up the offer of more information or not—this is not a prerequisite for visiting and enjoying the museum.

The backbone of communication at the Zentrum Paul Klee is what is called the Museum Street, and all roads to the interior of the museum lead along it. It forms a linear connecting element between the museum's three hills, and widens out into a piazza three times, once at the level of each of the hills. Thanks to its construction behind a 150-meter-long glass façade, the Museum Street is a transparent place where one can spend time, where one can promenade pleasantly before, after, or instead of visiting the exhibition. Unlike conventional museum foyers, it offers visitors a varied multimedia experience—free of charge, and accessible even outside the museum's opening hours. This makes it possible to get more out of a visit to the exhibition, to meet friends at the café, or to buy a gift in the museum shop. The squares all have a different makeup and atmosphere and offer an opportunity for communication, relaxation, or gathering information. The information provided offers insights into the function of each nearby hill with which each piazza is designed to be in direct correlation.

The piazza corresponding with the North Hill comprises a spacious foyer, primarily used for receiving guests and providing them with introductory information and orientation aids. But there is more available here than information on the spectrum of events and on the Zentrum Paul Klee as an institution; this is also home to the congress administration, the café, and a lounge, where newspapers and magazines may be read. As visitors to the Zentrum Paul Klee also leave via the North Hill, information on other cultural events and institutions in the region may be found in the foyer, along with practical tips on what to do while visiting Bern.

The shop runs the length of the piazza in the Middle Hill. Because it is important in helping the Zentrum Paul Klee become known around the world, it is an important communication platform. The selection—including books, reproductions, music, and other merchandise—is oriented along the lines of the Zentrum Paul Klee philosophy.

The South Hill piazza is home to the reference library. For those whose studies are even more intense, computer work stations are available. Among other functions, they may be used to access the center's complete database, including all ten thousand Paul Klee works. And, at the southern end of the Museum Street, there is an open area set up for film projection, where the Zentrum Paul Klee shows films on its work and cultural activities.

The computer work stations are a vital part of visitor communication and may be found in all three hills. Depending on their location, they inform the visitor about the cultural programs of the center and the city of Bern (North Hill); provide access to the center's database, and with it, to the collected works of Paul Klee (South Hill); or they offer thematic cross-references and background information on the works in the exhibition (Middle Hill/collection). Along the Museum Street, the demands on the center's services are especially high. Not only do we want to provide an inviting atmosphere, sufficient seating, and help with orientation, we want our staff to contribute to the wellbeing of guests with their friendliness, efficiency, and willingness to help.

Visitor communication is not limited to the things on offer in the Museum Street. This guide is intended first and foremost as an aid to preparation for a visit to the center, and as a means of looking back on it. But it is also a useful companion. The "museum guide" leaflet handed out at the reception with the ticket is the most compact guide through the building. It may be used like a pamphlet, but it also contains bar codes which may be used to "connect" with any computer work station in the building where more information can be found. The signs in the exhibition space for the permanent collection and the descriptions of each work are also essential elements in the visitor information system, as are the audio guides which will be available from 2006.

Visitors wishing to be guided personally through the center by the Paul Klee specialists working here can take advantage of the offer of tours on various topics in several languages. Please see our website (www.zpk.org), the quarterly program, or ask at the reception, for tours and other events currently available.

Pages 132/133
The Museum Street links the three hills at
the Zentrum Paul Klee, forming the main axis
of communication.

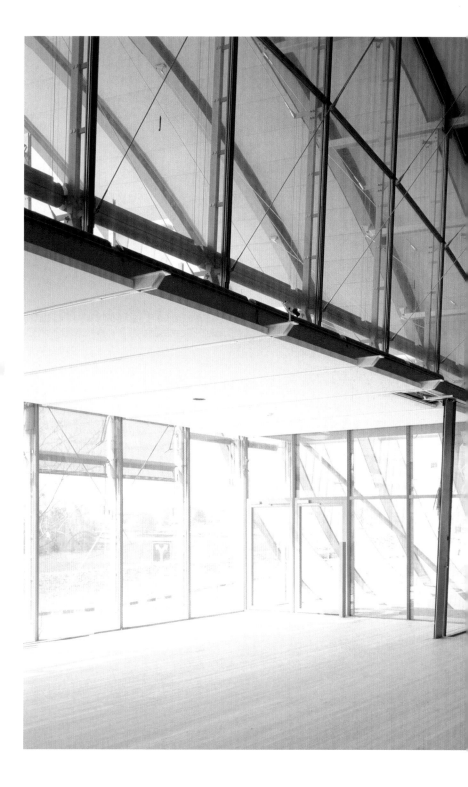

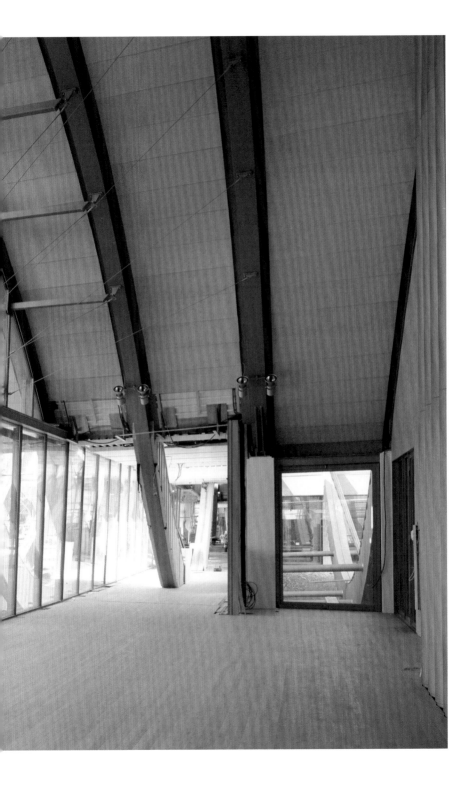

The Lovely Green: The Zentrum Paul Klee and Its Surroundings

Benedikt Loderer

Schöngrün. The name of the district means "lovely green" in German and says it all. Anyone who strolls along the path bordering the three hills of the Zentrum Paul Klee will be surrounded by a calming green environment. Like many painters and landscape designers before him, Renzo Piano employed a classic technique of using levels to make a structure (for more on his architecture, see pp. 23 – 30). In the foreground are the "hills" of the museum, followed by the middle ground of the trees in the gardens and at the edge of the wood, which flow on to the background of the surrounding wooded hills. The eye is guided such that it does not perceive the agglomeration of the city of Bern. One feels the woods reach as far as the horizon. Near and far meld into one another, and the green of the complex grounds appears like an island in a sea of trees. Piano has created a place secret and transported in its isolation. Yet the background of noise from the autobahn reminds us that we are in the midst of the city.

The view from Schöngrün to the serpentines of the hill in the adjoining
Schosshalden Cemetery, where Paul Klee is buried

Relief of the urban and rural categorization of the Schöngrün site (in the middle)

Bern Is Bigger

Schöngrün was a large tract of land in an area zoned for construction. Maurice E. Müller purchased the land from the Balsiger family in the seventies. In 1982, he set the ball rolling with a two-phase private competition for the site's future buildings. The lion's share of the property was subsequently built up, but one part remained empty. Müller originally proposed to put a residential and cultural center on the block, but this plan was never realized. A piece of land was looking for a new function. Müller decided to donate it to the public for a Klee museum. He commissioned Renzo Piano with the design.

Where is Schöngrün? In the middle of the edge of the city. The choice of Schöngrün raised many eyebrows. People in Bern say the city runs from Zytglogge to Loebegge; Schöngrün was a long way out, considered by many to be almost beyond the pale. Piano admired Bern's historical center but he did not know where the city's boundaries lay. He saw the context of the landscape and not the hierarchy of city districts. He contrasted the compact old town with the open spaces of Schöngrün and their natural extension through Wyssloch to the Egelsee lake, including the forested summit of the Ostermundigenberg. The Berners gained a new perspective on their home town. Bern was bigger than its inhabitants believed it to be. It finally made sense to accept the urban sprawl instead of focusing solely on the upper old town. It also meant that "ways to Klee" were needed in the new, bigger Bern. A network of roads has twenty-two signposts

Iron sculpture Loaraden, 1993, by Oscar Wiggli
in the Sculpture Park

guiding visitors from the main station to Schöngrün and a further ten leading
to the Ostermundigen quarries. The signs feature pictures Klee painted from
that point. The accompanying text outlines Klee's connections with the loca-
tion. This network of roads also creates a new link from Ostermundigen to
Murifeld.

The Block Next Door

The design began with a deep analysis of Paul Klee and the terrain. Renzo Piano
visited Klee's grave at the Schosshalden cemetery, where a grassy mound caught
his attention. He did not regard the autobahn as a necessary evil; he saw it as
a vital artery in the living city. He determined that the project would have to be
developed to work with the highway instead of against it.

Piano quickly convinced all those concerned that the land originally intended for
the museum was not appropriate. He suggested building the new museum in
an empty field reserved for the expansion of the cemetery. That land belonged to
the city of Bern and was in the industrial zone. Piano told the Bern newspaper
Bund: "We mustn't make it small; the whole thing has to be integrated into the
planning. As soon as we had decided to work on the basis of the entirety, the
matter was no longer one of just a building—it was about a place. And so, from
then on, we regarded the site as a sculpture and worked the field like farmers."

Villa Schöngrün at the northern entrance to the grounds
(before the conversion into the restaurant), 2004

The park—or rather, the 2.5 hectare landscape sculpture behind the "hills"—is now framed by a drop with steel railings. It draws a border between the sculpture and the surrounding land. A row of birch trees hems the footpath which runs around the edge. The whole area is farming land once more. With each passing season, the park finds an agricultural use. The space is planted uniformly—Bern will be the first city to employ an art farmer.

The Sculpture Park

The Sculpture Park is an integral part of the landscape sculpture. One of the founders of the Zentrum Paul Klee, Martha Müller, a longtime patron of music and passionate collector of contemporary art, expressed her willingness in 2002 to make part of her collection accessible to the public. To this end, she had the Renzo Piano Workshop and the landscape gardeners Eduard Neuenschwander and Anja Bandorf build the Sculpture Park at the far southeastern edge of the landscape sculpture. Figures by Oscar Wiggli, Alicia Penalba, and others stand unobtrusively and comfortably in a garden, inviting visitors to relax and enjoy.

Renzo Piano: "We regarded the site as a sculpture and worked the field like farmers."

La Campagne

Villa Schöngrün stands next to the museum, forming the entrance on the northern side of the site. The heritage-listed building has been carefully renovated, complemented with a glass annex, and converted into a fine restaurant. But that is just the latest chapter in its history, and it will not be the last.

Villa Schöngrün is a reminder of the *campagnes*, the country residences of Bern's wealthy elite, a reminder of the high-spirited splendor of their summer seats. Schöngrün—it could be the name of a country residence in the dialect novels by Rudolf von Tavel. It is a house from Bern's pre-industrial days, emanating the spirit of an era long past. The aura of the ancien régime still surrounds the villa; it will never disappear from Bern.

This villa is—without anyone realizing it beforehand—similar in essence to the Zentrum Paul Klee. Because it has room to breathe. Because it is a large building in a large garden which passes into farmland. Because there are no other properties pressing in on it, no thick hedges necessary to stop the neighbors peering in—in short—because the Zentrum Paul Klee has been planned on the scale of a country residence. "We mustn't make it small,"—Piano's instinct was right—things that are great in themselves need greatness around them.

Practical Information

How to Find Us

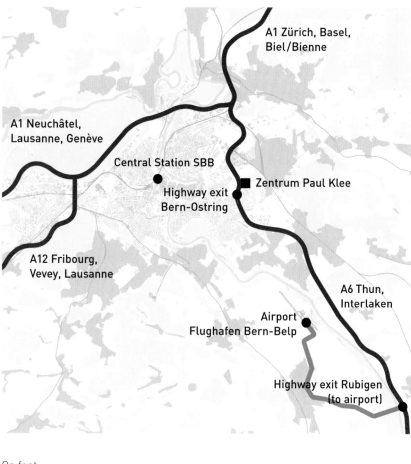

On foot
"Wege zu Klee" (Paths to Klee); "Schritte für Klee" (Steps for Klee)
Bus
Number 12 in the direction of Zentrum Paul Klee/Schosshalde to last stop
Tram
Number 5 in the direction of Ostring to last stop
Autobahn
A6, exit: Bern-Ostring
Parking
150 parking spaces, parking for busses and bicycles available on site

The Zentrum Paul Klee can be reached by public transport in little more than ten minutes from Bern's main station.

Orientation in the Grounds and Surrounding Area

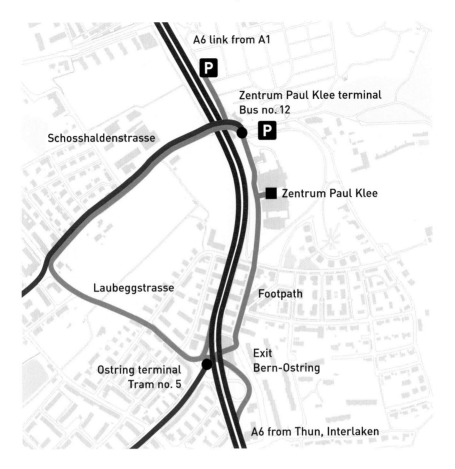

Address
Zentrum Paul Klee
Monument im Fruchtland 3
3006 Bern
Phone: + 41 (0)31 359 01 01
Fax: + 41 (0)31 359 01 02
E-Mail: kontakt@zpk.org
www.zpk.org

Recorded information
Phone: + 41 (0)31 359 01 03
Emergency number during events
Phone: + 41 (0)31 359 01 00

Opening Hours

Collection/Exhibitions
Mon closed
Tues–Sun 10 a.m.–5 p.m.
Thurs 10 a.m.–9 p.m.

Museum Street/Shop/Café
Mon closed
Tues–Sun 9 a.m.–6 p.m.
Thurs 9 a.m.–9 p.m.

Kindermuseum Creaviva
(Children's Museum)
Open Studio: as for Collection/
Exhibitions
School and other groups:
as for Museum Street (when visit has
been booked in advance)

Graphic art room
Thurs 2–6 p.m.
(advance booking necessary)

Archive
By arrangement

Restaurant Schöngrün
Mon closed
Tues–Sun 11 a.m.–11.30 p.m.

Special opening times of all services
possible by arrangement

Contact

Zentrum Paul Klee

Administration
E-Mail: direktion@zpk.org

Archive/Graphic Art Collection
E-Mail: archiv@zpk.org

Art Information (guided tours)
E-Mail: kunstvermittlung@zpk.org

Collection/Exhibitions/Research
E-Mail: forschung@zpk.org

Communication and Information
E-Mail: kommunikation@zpk.org

Facility Management and
Administration
E-Mail: facilities@zpk.org

Kindermuseum Creaviva
E-Mail: kindermuseum@zpk.org

Music
E-Mail: musik@zpk.org

Shop
(not for museum information)
E-Mail: shop@zpk.org

Café and Restaurant

Restaurants Schöngrün
Monument im Fruchtland 1
3006 Bern
Phone: +41 (o)31 359 02 90
Fax: +41 (o)31 359 02 91
E-Mail: info@restaurants-
schoengruen.ch
www.restaurants-schoengruen.ch

Café (in the complex)
Phone: +41 (o)31 359 02 92

Foundations

Fondation du Musée des Enfants auprès
du Centre Paul Klee
E-Mail: fme@zpk.org

Maurice E. and Martha Müller
Foundation
E-Mail: mmmf@zpk.org

Stiftung Sommerakademie
(Summer Academy Foundation)
E-Mail: sommerakademie@zpk.org

Stiftung Zentrum Paul Klee
E-Mail: szpk@zpk.org

Services

Further information on the services offered, as well as on our program, is available on our website: www.zpk.org.

Collection

The ground floor of the Middle Hill has a space comprising 1750 square meters for the presentation of the collection (more than four thousand works by Paul Klee). Some three hundred works are on display at any one time, offering insights into the *oeuvre*.

The center is oriented toward interdisciplinary work based on the complex personality of Paul Klee. The presentation aims to make this real and visible to visitors by offering an important impetus for the center's musical and educational programs. In order to be able to show this unique collection to a wide audience, the works on display are changed regularly or presented in a fresh context.

Special Exhibitions

The ground floor of the Middle Hill comprises an area of 830 square meters which can be divided up for changing exhibitions. About four special exhibitions will be put on here each year. Their main themes will be Paul Klee's cultural, historical, and artistic environment, and the ramifications the artist's work has had into the twenty-first century. All these special exhibitions are directly linked to Klee and are aimed at complementing the current presentation of the regular collection. More specifically-themed exhibitions are shown in the forum (North Hill), on the Museum Street, and in the children's museum.

Museum Street

All public access ways to the Zentrum Paul Klee cross the Museum Street, which runs parallel to the autobahn and provides a functional, thematic, and aesthetic link between the museum's three hills. Behind its 150-meter-long glass front, the Museum Street is a pleasant place to sit and talk or walk up and down. At the same time, traditional and electronic media are accessible here, allowing visitors to prepare ahead of their viewing of the exhibition or to ponder it afterward, and informing them about the cultural experiences on offer in Bern. A digitized version of Paul Klee's entire *oeuvre* of some ten thousand works is accessible via the computer terminals.

The Museum Street contains the reception and information area, the café, the conference administration, the shop, a reference library, and an orientation and information system. In the open ground floor of the North Hill, the Museum Street

continues in the loft of the children's museum. Themed exhibitions here focus on additional aspects of Paul Klee's life and work. The Museum Street and its facilities are free of charge and are open for longer than the exhibitions. (Museum Street: Tues–Sun 9 a.m.–6 p.m., Thurs to 9 p.m.; exhibition areas: Tues–Sun 10 a.m.– 5 p.m., Thurs to 9 p.m.)

Guided Tours and Events

Paul Klee was a painter, musician, teacher, philosopher, and writer. Based on the many complex levels of his personality and on his inspiring *oeuvre*, the Zentrum Paul Klee offers a program of events encompassing the classic guided tours on art and architecture, themed events and performances, conferences and symposia, as well as theatrical and musical productions. Art, music, theater, and literature do not merely have parallel existences at the Zentrum Paul Klee, they interact to find new forms of expression.

Archive and Graphic Art Collection

The collection/exhibition/research department is open by appointment to students, researchers, and specialists, as well as the interested lay public. The department includes a special library as well as an image database and a comprehensive documentation of the works. Those who have made an appointment can see drawings and sketches on a Thursday afternoon in one of the seminar rooms. Employees at the center are available to give their expert advice and information on any aspect of Paul Klee and his work.

Kindermuseum Creaviva and "Open Studio"

At the children's museum Kindermuseum Creaviva, children, families, and school groups have a large selection of educational choices, both modular or which can be put together to suit the individual. In a space of seven hundred square meters there are studios, course and exhibition rooms, which can be made available by arrangement. Children four years old and up are welcome, as are adults wanting to explore the artistic possibilities of their own imagination and creativity. A special feature is the Open Studio, where visitors may attend one-hour workshops dealing with Paul Klee themes. No appointment is necessary for these workshops.

Summer Academy

The Zentrum Paul Klee summer academy will be open for ten days each summer starting from 2006. It is directed at artists wanting to build upon their skills at a high level. Particular qualifications are required, and numbers are limited. Students whose performance within the framework of the academy is excellent will receive a scholarship with which to realize their academy project, which will then go on public display during the summer academy of the following year. The summer academy is intended to be a lively forum for teaching and cultural exchange. For this reason, a parallel evening course will be offered, open to members of the public.

Membership

Would you like to benefit from concessions or demonstrate your solidarity with the Zentrum Paul Klee with an annual contribution? We would be very pleased if our membership model has a kind of membership to suit you.

Booking Rooms

The Zentrum Paul Klee is an ideal venue for conferences, congresses, and conventions in combination with an attractive side programs. A number of multi-purpose rooms provide space for between thirty and three hundred people and are fitted with the latest electronic media and equipment necessary for concerts, multilingual symposia, and seminars. All rooms have wheelchair access.

Gastronomy/Catering

At the Zentrum Paul Klee, we like to spoil our guests—not only culturally, but culinarily as well. For our gastronomical facilities, we were able to engage top chefs Werner Rothen, formerly head chef of gastronomy at the Schweizerhof Bern, and Nadine Wächter, formerly head chef of the Schultheissenstube im Schweizerhof, which has 16 Gault Millau points.

The Schöngrün restaurants comprise the Restaurant Schöngrün next to the center (with salons for small groups), the modern café on the Museum Street, as well as catering available for groups of twenty or more. Nadine Wächter and Werner Rothen offer fresh cuisine in a fine bistro atmosphere.

All the eateries at the Zentrum Paul Klee are run by ZFV-Unternehmungen. This respected Swiss catering company runs its own hotels (Sorell) as well as numerous restaurants and canteens. Quality and friendliness are the company's trademarks. In the Schöngrün restaurants, the quality of the Zentrum Paul Klee art and architecture is carried over into the food.

The Grounds and Nearby Area

Landscape Sculpture
The Zentrum Paul Klee appears as three architectural hills rising gently from the surrounding grounds. Architecture and nature form a 2.5 hectare landscape sculpture which makes the center unique. The grounds are bordered by a public path.

Sculpture Park
Martha Müller-Lüthi, a keen patron of music for many years, is also a passionate collector of contemporary art. She commissioned the Renzo Piano Workshop and landscape architects Eduard Neuenschwander and Anja Bandorf to create a sculpture park at the southeast edge of the grounds, in which to display a part of her collection with works by Alicia Penalba, Oscar Wiggli, and Yves Dana.

Paths to Klee/Steps for Klee
A themed orientation and information system (Paths to Klee) guides pedestrians to the Zentrum Paul Klee, to the center of Bern, and to the Ostermundiger quarries—an important site for some of Paul Klee's paintings.
Eighteen access routes to the Zentrum Paul Klee have been named after titles of works by the artist. All the relevant drawings, watercolors, and paintings by Klee, a graphic overview of the renamed roads and routes, as well as information on the history of the project are listed in the publication *Schritte für Klee,* available at the shop in the complex.

Schosshalden Cemetery
Adjoining the Zentrum Paul Klee is the Schosshalden Cemetery, where Paul Klee was laid to rest. That the Zentrum Paul Klee was able to come into being here was a stroke of fate.

Index of Titles

This is a register of works discussed in this guide (pp. 60–111).

Photo Credits

All photos of Paul Klee's works (with the exception of p. 91): Peter Lauri, Bern, and Abteilung für Bild- und Medientechnologien, Basel University

Felix Klee, Zentrum Paul Klee, Bern, Klee Family Donation:
Frontispiece, p. 9 (top), pp. 38, 77, 111 (left)

Franz Henn, Zentrum Paul Klee, Bern, Archive Bürgi: p. 9 (bottom)

Lily Klee, Zentrum Paul Klee, Bern, Klee Family Donation: p. 10

Photographer unknown, Zentrum Paul Klee, Bern, Klee Family Donation:
pp. 11, 32, 33, 35, 37, 123

Peter von Gunten, Bern:
p. 12 (top), 18, 19, 134, 137, 138

Jens-Erik Nielsen, private collection, Bern:
pp. 12 (bottom)

Kunstmuseum Bern: p. 13

Hansueli Trachsel, Kunstmuseum Bern:
p. 14

The Menil Collection, Houston: p. 15

Renate Joss, Bern, private collection, Bern:
p. 16

Dominique Uldry, Bern: pp. 17, 22, 24, 25, 28, 29, 31

Renzo Piano Building Workshop, Genoa and Paris: pp. 27 (Michel Denancé), 124, 135

Karl Schmoll von Eisenwerth, Zentrum Paul Klee, Bern, Klee Family Donation: p. 34

Louis Moilliet, Westfälisches Landesmuseum für Kunst und Kulturgeschichte, Münster:
p. 36

Musée national d'art moderne, Paris, Centre Georges Pompidou, Fonds Kandinsky: p. 39

Franz Aichinger, Zentrum Paul Klee, Bern, Klee Family Donation: p. 41

Charlotte Weidler, Zentrum Paul Klee, Bern, Klee Family Donation: p. 43

Gerhard Howald, Bern: p. 91

Walter Henggeler, Fotopress, Zürich: p. 109

Peter Lauri: pp. 110 (left), 114, 115, 116, 118

Abteilung für Bild- und Medientechnologien, Basel University: pp. 110 (right), 119, 120

Christian Mattis, Bern: p. 125

Adrian Weber, Kindermuseum Creaviva, Zentrum Paul Klee, Bern: p. 128

Erwin Schenk, Zentrum Paul Klee, Bern:
p. 136

Editor
Zentrum Paul Klee, Bern

Editing
Michael Baumgartner and Ursina Barandun

Authors' abbreviations
Michael Baumgartner MBA;
Nathalie Gygax NG
Cornelia Luchsinger CLU
Tilman Osterwold TOS
Anna Schafroth AS
Eva Wiederkehr EWS

Copyediting
Ingrid Nina Bell

Translations
Amanda Crain

Graphic Design and Typesetting
Atelier Sternstein, Stuttgart

Typeface
Sabon, FF DIN

Reproduction
Pallino cross media GmbH, Ostfildern-Ruit

Binding
Schumacher AG, Schmitten

Paper
Printed on Furioso 150 g/m² from
m-real Biberist, Switzerland

Printed by
Benteli Hallwag Druck AG

Maps pp. 140, 141
Reproduced with permission of Vermessungs-
amt der Stadt Bern of April 13, 2005

Published by
Hatje Cantz Verlag
Senefelderstrasse 12
73760 Ostfildern-Ruit
Germany
Phone +49 (0)7 11 440 50
Fax +49 (0)7 11 440 52 20
www.hatjecantz.de

Hatje Cantz books are available internation-
ally at selected bookstores and from the
following distribution partners:
USA/North America – D.A.P., Distributed Art
Publishers, New York, www.artbook.com
UK – Art Books International, London,
sales@art-bks.com
Australia – Towerbooks, French Forest
(Sydney), towerbks@zipworld.com.au
France – Interart, Paris,
commercial@interart.fr
Belgium – Exhibitions International, Leuven,
www.exhibitionsinternational.be
Switzerland – Scheidegger, Affoltern am Albis,
scheidegger@ava.ch

For Asia, Japan, South America, and Africa,
as well as for general questions, please contact
Hatje Cantz directly at sales@hatjecantz.de,
or visit our homepage www.hatjecantz.com
for further information.

ISBN 3-7757-1536-3

This short guide is also available in French
and German
ISBN 3-7757-1537-1 (French)
ISBN 3-7757-1535-5 (German)

Printed in Germany

Frontispiece
Paul Klee with the cat Fripouille, Possenhofen,
1921

BEKB | BCBE

BKW®
BKW FMB Energie AG

coop

CREDIT
SUISSE

Die **Mobiliar**
Versicherungen & Vorsorge

FONDATION
MAURICE E. MÜLLER

GALENICA

SECURITAS

swisscom

SWISSLOS
Lotteriefonds
Kanton Bern

UBS

AO Foundation

AMMANN

BUNDESAMT FÜR KULTUR
SWISS FEDERAL OFFICE OF CULTURE

HOFSTETTER

The Mathys and
Marzo families
Bettlach